D1422925

The Work of E H Shepard

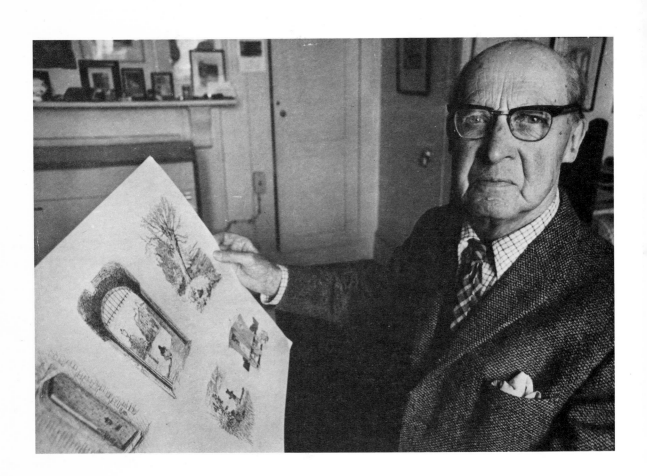

The Work of E H Shepard

Edited by Rawle Knox

METHUEN · LONDON · NEW YORK · SYDNEY · AUCKLAND

First published by Methuen Children's Books Ltd,
11 New Fetter Lane, London EC4P 4EE
Copyright © 1979 Methuen Children's Books
Designed by Ray Carpenter

Printed by Hazell Watson & Viney Ltd,
Aylesbury, Bucks

British Library Cataloguing in Publication Data

Shepard, Ernest Howard
 The work of E. H. Shepard.
 1. Shepard, Ernest Howard
 2. Illustrations – England – Biography
 I. Title. II. Knox, Rawle
 741'.092'4 NC978.5.S1

 ISBN 0-416-86770-7

Contents

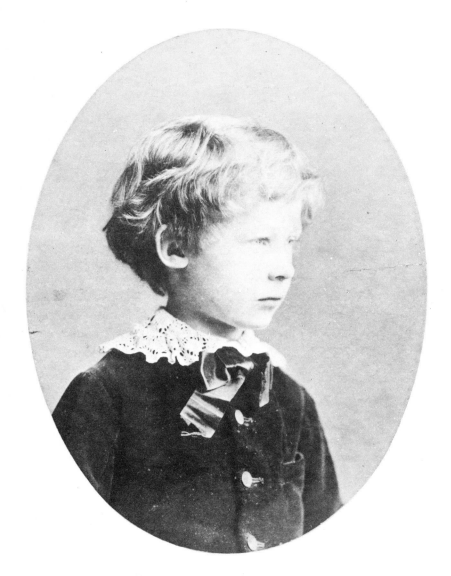

Young Ernest at the age of eight.

Preface

I suppose I first met Ernest Shepard in the late 'twenties when he was illustrating some verses my father (Evoe) was writing for *Punch*, and he came at times to our home in Hampstead – as much socially as professionally. I was still at school then, and my acquaintance was made at a respectful distance. I remember from the beginning that Mr Shepard's ineluctable optimism would on occasion mildly exasperate my father (who sustained the unconquerable despair of a true humorist), but that never seemed to interfere with their friendship. Mr Shepard became 'Kipper' to me when his daughter Mary married my father, by then widowed, in 1937. The relationship of step-grandfather to step-grandson enjoins no special intimacy, but it could not, with Kipper involved, lack friendliness. As for his work, I am sure it first made marked impact on me with the drawings for A.A. Milne's *When We Were Very Young,* verses which first appeared in *Punch* in 1923 (I was not quite ten at the time). Of course I knew Kipper's illustrations before then – I was reared reading copies of *Punch*, old and new – but that was the first time, the first of many, many times, that he spurred in me the quick hop-skip of an inner smile (Milne helped of course); and I started looking back in the bound volumes for his drawings.

It was never easy to relate the man to his work, as somehow it was with, say, Stampa, or George Morrow. By the beginning of the last war, when I knew Kipper better, I probably talked to him far more often about gunnery than about books, journalism or art. (It is, by the way, pure coincidence that Kipper, Humphrey Ellis, who contributes the chapter on 'Ernest at the Punch Table', and myself all served with the Royal Artillery; but one that Kipper, I think, would approve of). I really only began to learn about him, about his professionalism and the breadth of his artistic field when I undertook to prepare this book.

It is a book to commemorate an artist who was born one hundred years ago this December 10 (1979), and who died on March 24, 1976 (the same day, incidentally, as Lord Montgomery of Alamein, whom Kipper much admired and who was eight years his junior). If 'commemoration' sounds too sombre a description, let us call it a book by which to remember the lightness and movement Kipper gave to everything he

drew or painted. The text is not a biography, but it traces the outline of
Kipper's life so that the main events can be seen as a background to the
work he was doing at any time. I have laid most emphasis on his early
life and World War I experiences, partly because he himself has written
of his boyhood and his years as an art student (and he, surely, is the best
source, even if the gap of years does sometimes stretch his memory out
of focus); but more than that, because the manner of his introduction to
the world certainly dictated the order by which he steered himself
through it. Kipper was what is now called 'an establishment man';
Punch helped; *Winnie-the-Pooh* helped even more, and he ended as a
pillar of Sussex society. I have the strong impression that Kipper knew
all along where he was going, and confidently expected to get there. As
for his first world war experience: he had always hankered after the life
of a soldier, and in 1915 he became one. It so happened that he became a
very good one, and he returned to civilian life pretty sure he could do
what he wanted to do. Not long after the war, by the early 'twenties
anyway, the line of his drawing had become more precise and assured.
He no longer strained to try and make people's faces look funny; he
drew them as he knew they were.

This is very much a family book. Penelope Fitzgerald, my sister, has
written a chapter admirably explaining the influences on Kipper's early
work. Humphrey Ellis became practically a relative-by-labour during
long after dinner hours on Thursdays, making up next week's *Punch* at
home with my father. If the cartoon was ready, Kipper often brought it
round there and stayed for a drink or two. Invaluable help – in truth,
the bulk of the work – has come from Mary, my ever-thoughtful
stepmother, and from Minette Hunt, Kipper's only surviving
grandchild. They have researched, revised and corrected, they have
allowed me to pick from their considerable collections of Kipper's
work, especially sketches. Anna Shepard, Kipper's daughter-in-law,
was kind enough to give me her description of the artist at work. I am
very grateful also to Leslie Illingworth, who remained a friend of
Kipper's to the last, for talking to me at such length. All I have done is
to edit what others have written or said. If there should be any errors or
misjudgments, the fault is mine alone.

The pictures by Ernest Shepard in this book range from boyhood
sketches to colour work in his old age. He first exhibited at the Royal
Academy in 1901, and was still drawing and colouring for publication
in 1973. Almost all he ever did has been preserved, and a number of
sales, both before and after his death, has dispersed much of his work

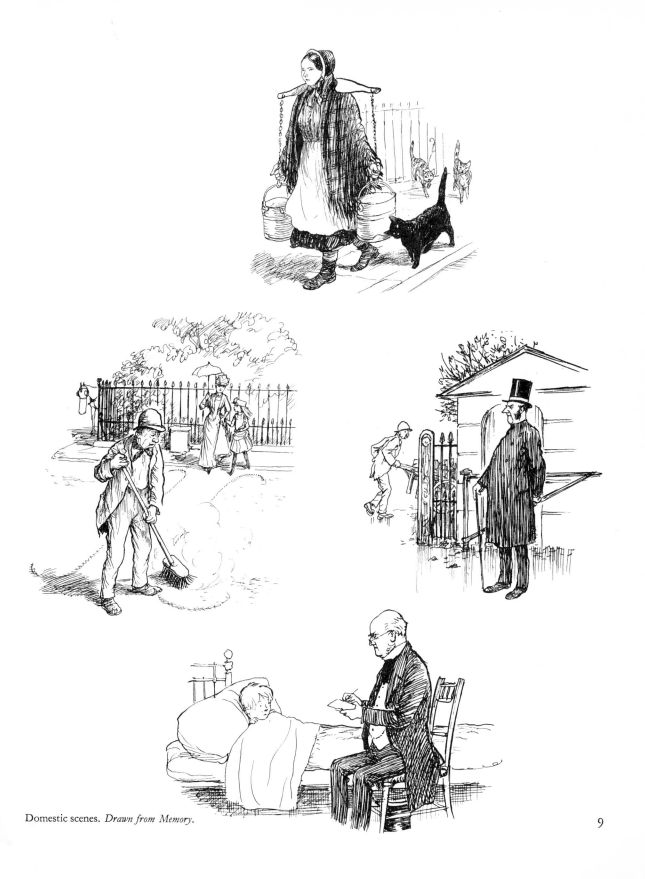

Domestic scenes. *Drawn from Memory.*

9

around the world. What I have gathered here is, I believe, representative of the body of his best output, and if there are those who miss a special personal favourite, I beg their forgiveness. Three main targets I have aimed at: to present examples of Kipper's art from every period of his career; to indicate the importance of his sketches, which often show more detail than the finished work (though are not necessarily more effective); and, for those whose love of Shepard is inseparably bound up with the Winnie-the-Pooh stories and/or Kenneth Grahame's *Wind in the Willows*, to include colour sections that are fully representative of his decorations for those books.

I can only hope that all who are as fond of Kipper's work as I am will enjoy themselves.

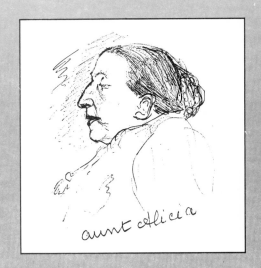

1879-1897

A Victorian boyhood

The year Ernest Shepard was born was also that in which the Prince
Imperial, son of Napoleon III and of the Empress Eugénie, by then a
good friend of Queen Victoria, died fighting for the British in the
Zulu War. In measurement of worlds apart, that seems to take me back
more than a mere hundred years. I chose the event because I felt that its
romantic and martial echoes would appeal to Shepard. 1879 was also
the year when Gladstone finally dished Disraeli with the ferocious
oratory of his Midlothian campaign – and, incidentally, that in which
Joseph Stalin was born. Neither event would have much interested
Shepard who was to write, when accepting Sir Owen Seaman's
invitation in 1921 to join the staff of *Punch*: 'I cannot pretend to have
anything more than a working knowledge of politics.' (It was a work-
ing knowledge that enabled him later to remain a *Punch* political
cartoonist for over twenty years).

He was born, of imaginative parents, into a world which he found
romantic almost as soon as he could use his eyes and ears. His father,
Henry Donkin Shepard, was an architect, and his mother, born Jessie
Harriet Lee, was the daughter of a distinguished water-colourist.
Henry was a keen water-colour painter, and both parents also enjoyed
themselves on the fringe of the theatrical world. They were good
amateurs, and were sufficiently bitten to hang in the professional wings.
Henry Irving once offered Henry a place in his company. 'Father,' wrote
Ernest Shepard, 'knowing the hazards of an actor's life, wisely refused.'
The hazards were more than financial. Professional actors, unless they
became as successful as Irving, were not yet accepted in 'decent society' –
and the same, of course, applied to struggling artists – though, truth to
tell, a young architect was not much higher up the ladder.

The Shepards and the Lees both considered themselves, and were
considered, most respectably middle class. They came however from
widely separated drawers in that solid cupboard of English stock,
as we shall see. Henry's father had been a member of Lloyd's,
and established himself in Tavistock Square while he built a grander
new house in neighbouring Gordon Square – where he died almost as
soon as it was finished. That was in the 1850s, when coroneted society
was moving south and west out of that quadrangle bounded by Euston
Road, Tottenham Court Road, Woburn Place and Great Russell Street,
and its place was being taken by the more successful of those in 'Trade'
and 'Commerce'. Old Shepard had also built a house on Guildown,
near Guildford, and was clearly a man of substance. Nevertheless, since
he had four sons and seven daughters, that substance was to be spread

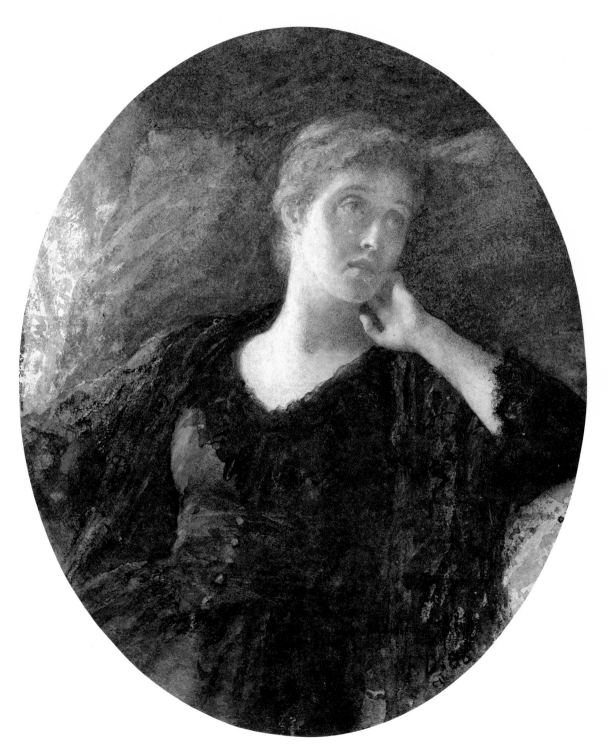

Jessie Shepard (née Lee), Ernest's mother, was the daughter of a
distinguished water-colourist. This oil sketch is by a family friend,
Frank Dicksee, RA, who used it for his Academy portrait, *Memories*. 13

fairly thin and, as so often in Victorian families, not very equally, among following generations.

By the time young Ernest Shepard was fully conscious of his aunts, four of those seemingly old ladies were still living at 53, Gordon Square. One had already died, two had moved out of the family home; none ever married. Perhaps that was not their fault, since their father had constantly refused to allow any young man to come to the house or to let one of his daughters beyond the front door without a chaperone. One of the uncles had died too, and the eldest survivor, 'Willie, our favourite Uncle', had been to Balliol, taken holy orders, and become a schoolmaster at St Paul's; the other, Robert, took his father's seat on Lloyd's and was prudently made Ernest's godfather. Obviously there was not very much left for Henry, the youngest son. We do not know whether he chose to become an architect – still not really a profession for gentlemen unless under patronage – or whether he was 'placed' by his family, but his early keenness for painting and drawing suggests that the decision may have been his own.

After his father's death, Henry Shepard lived with his sisters at the big house in Gordon Square, and when he started architectural practice he walked to work at an office in Great Marlborough Street – the distance is only about a mile. The start of his route took him through Byng Place and under the windows of the Lee house on the corner of Torrington Square. Jessie, whose father, old William the painter, had died some fifteen years before, could see him every day from her bedroom window. This was a very different home from the one across the way, where old Shepard's hand still seemed to reach out from the grave to restrain all sinful frivolity. William Lee had married a sixteen-year-old girl, now a widow and as much an elder sister as a mother to Jessie. Most of those who were anyone in the art or theatre world came and went through the house in flickers of light and laughter. Lizzie, who went to Torrington Square when she was only seventeen to be Jessie's nurse, and who later moved on to look after the young Shepards when Jessie married Henry, used to tell Ernest that she thought 'Arthur Sullivan was sweet on your Mama'. The Dicksee family (the father, Thomas, was a portrait painter, and a son was later to become Sir Frank Dicksee, President of the Royal Academy and a great helper of Ernest) were constant visitors to the Lees. Ellen Terry was a friend of the young Mrs Lee, and Johnston Forbes-Robertson came often. It is hardly surprising that Henry's sisters should have had grave misgivings when he began calling on Jessie.

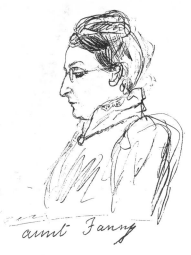

aunt Fanny

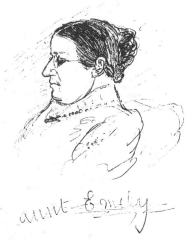

aunt Emily

Two Gordon Square aunts, as Ernest saw and drew them when he was about ten. (Aunt Alicia is on page 11)

The young Ernest: almost certainly by his father,
strongly influenced by Frank Dicksee.

The pair married in 1874, and went to live in a tiny house in the royally named Boscobel Place, which before long was knocked down to make way for the construction of the surrounds to the new Marylebone Railway Station. The young Shepards moved, still in the St John's Wood area, to 55 Springfield Road, which runs north-eastward off Abbey Road. There Ernest Shepard was born. (December 10, 1879.)

In choosing Jessie Lee, Henry Shepard must have appeared, at any rate to his family, as something of a rebel. Strictly speaking, Trade had married Art, a far rarer event for the times, and one more likely to shock, than Nobility marrying The Stage. But in fact Henry and Jessie were apparently a very normal middle class couple, if perhaps rather less inhibited than most of their contemporaries. They lived in St. John's Wood because it was a 'nice' neighbourhood, but not yet too expensive, a village clinging to the western edge of Regent's Park. 'Behind . . . the approaches to Marylebone station,' wrote Ernest Shepard in 1957, 'was an acreage of small and pleasant Georgian houses, as there are to this day around Lord's Cricket Ground. They had brick-walled gardens and quiet roads . . . ' It was the kind of district the young Shepards would want, and expect to live in, though they were by no means well off. If Henry Shepard had been in any way frightened, or ashamed of the step he had taken in life, he would not have decided that his much loved younger son, Ernest, should become an artist. 'Some of my early efforts at drawing,' wrote Ernest, 'were shown, with a certain pride, by my father to his artist friends. Father had quite decided that I should be an artist when I grew up, though I myself considered an artist's life to be a dull one and looked for something more adventurous.' From Henry Shepard's viewpoint, to become an artist must have been about as adventurous as you could get (and still retain your caste). But he was prepared to push his son along that road because he had made an in-stinctive judgment that you could get the best out of the caste system by stretching it to its limits.

If I have laid stress on the family background, it is because the social scene played formally out before that solid landscape, influenced the individual so much more than it is ever likely to do again. Lord John Russell's Reform Bill of 1832 had given the middle class the vote for the first time, and so virtually brought it into corporate existence; it took about fifty years for it to sort itself out – and into its chosen hier-archical shape. By that time everyone knew everyone's station in life with some exactitude, but – more than that – the middle class as a whole knew its position in the national scheme of things and it had come

Life at Gordon Square: cleanliness and godliness.

firmly to support what in later, less reverent days, was to be called The Establishment. We know from the comedies of Barry Paine's Eliza and George Grossmith's Pooters how tragic the struggle could be to retain one's status as a gentleman. All the same there was this common bond; between the comfortable *commerçant* who affected to shudder at what went on behind the scenes in Drury Lane, and the actor who scoffed at the dreadful thought of being a city clerk (though, on occasion, with some sympathy; Ernest, the young artist, uncertain where he could place his next picture, was full of pity for his elder brother Cyril, setting off to work for a regular wage as a clerk in Lloyd's). No one brought up in this society in the second half of the 19th century, as both Ernest and his father were, could fail to receive the imprint of knowledge of Victorian right and wrong, correctness and deviation. Henry Shepard may have appeared bohemian to some of his contemporaries, but Ernest found him a stern enough father, even though he could be a good friend. (Jessie never managed to feel comfortable with the aunts, in the formidable home at Gordon Square.) Inevitably the same mores were passed on to Ernest, but I always feel it unfair that he encountered later in life some criticism (not, I think, that it ever worried him) on the grounds that he was a bourgeois artist drawing bourgeois children. In fact he could, and did, draw everything, but he was most in demand for what he did best, which was illustrating books likely to sell in the profitable middle class market.

Drawn From Memory, published in 1957, is the fascinating book in which Ernest Shepard threw together a number of sketches and stories, as he used to tell them to his own children, about his early youth. Here he has taken (very roughly) his own eighth year, which was that of Queen Victoria's Golden Jubilee, 1877. By that time Henry and Jessie, with their children Ethel, Cyril and the latest born, Ernest, had moved to 10 Kent Terrace, on the westward outskirts of Regent's Park, looking out on to Park Road. He tells stories of staying with the aunts, of home and school and trips to the Zoo and Hampton Court Palace, of the great fire at Whiteley's shop in Westbourne Grove, of visits to the country and the seaside, of a street assault on a policeman, and of course of Christmas, pantomime and the Jubilee. His tales, told in a rarely broken atmosphere of happiness, vividly describe an age, and yet say even more about the author. Much, much later, some who encountered Ernest Shepard's apparently indestructible smile of optimism concluded, either in envy or disdain, that he drew such good pictures for children because he remained the perennial child. Nothing could be further from the truth. He was a serious professional, a good

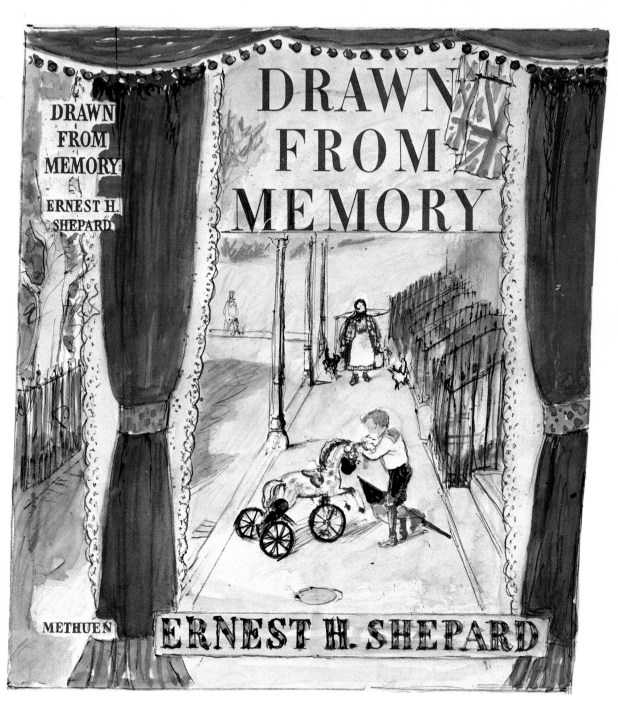

Shepard's original design for the dust-cover of his autobiographical
Drawn from Memory, featuring his adored tricycle-horse.

Family recreation in St John's Wood.
Drawn by Ernest at the age of eight or nine.

Same period. Ernest's preferred scenes of battle and bustle.

father, and a shrewd businessman. He did however have that rare
ability to cast his mind back into that of a child and, being an artist, to
see as the child saw, as well as to think that way. *Drawn From Memory*
has an unmistakably boyish gusto; and just occasionally there break in
flashes that illuminate the kind of man the writer (by then a mature
gentleman of seventy-eight) will become.

What, for instance, are we to make of the party at Dr Davis's house,
opposite the aunts in Gordon Square? 'It was a real children's party . . .
but there were some grown-ups, including a man with a loud booming
voice who kept us all in roars of laughter. His name was Whymper,
and Mrs Davis told us he used to climb mountains.' Or, at the mention
of his grown-up friend Mary Milner, whose fiancé was 'a young
journalist named Alfred Harmsworth'? 'He played cricket with us in a
field near our lodgings and showed Cyril and me how to bowl overarm.
He started a paper called *Answers* and, with two other young men,
made a lot of money.' They could, of course, just be marvellous throw-
away lines; the passing reports of a child to whom cabbages and kings,
when met for the first time, are of equal importance, deserving equal
news space. But when young Ernest goes to see *Babes in the Wood*, his
Christmas pantomime, his appreciation is altogether more precocious.

'I remember a gay young woman with prominent teeth and a flaxen
wig who sang and danced bewitchingly. She could only have been
Marie Lloyd, the unforgettable, aged seventeen and in her first
pantomime at the "the Lane". In the Harlequinade the clown was an
old favourite, Harry Payne, so Father told us, who had been clowning
for years and was shortly to give way to another famous clown,
Whimsical Walker . . . I did not think it possible that such feminine
charms existed as were displayed by the Principal Boy. Ample-bosomed,
small-waisted and with thighs – oh, such thighs! – thighs that shone and
glittered in the different coloured silk tights in which she continually
appeared. How she strode about the stage, proud and dominant,
smacking those rounded limbs with a riding crop! At every smack, a
fresh dart was shot into the heart of at least one young adorer. I had a
grand feeling that it was all being done for my special benefit; the whole
performance was for *me*; the cast had all been told to do their best
because *I* was there.' The only moment of dismay he suffered was when
he looked round and saw his father in the back of the box, reading a
newspaper – presumably to demonstrate the worldliness gained in his
long Thespian experience!

British soldiers run from Majuba Hill. To young Ernest the idea
was unthinkable, but the scene was flatly reported in a letter from
an uncle in South Africa.

There, I am sure, wrote the Ernest Shepard of all ages. The gorgeous women and the glittering stage were real, genuinely worth remembering and discovering something about. Edward Whymper might have been the first to climb the Matterhorn. Alfred Harmsworth, afterwards Lord Northcliffe, might have founded the *Daily Mail* and bought *The Times*, but neither was of abiding interest to an Ernest Shepard of either eight or seventy-eight. Perhaps he was not told of Whymper's wood engravings, but even they might not have touched a chord. There is an ecstatic account in *Drawn From Memory* of a visit to Hampton Court, when the picture galleries were the main object of his attention; not, however for the manner in which the paintings were composed, but for the splendid costumes and battle scenes they presented. Of course he was only eight years old, and of course his own pictures were still mostly of blood and battle. Of course his father's idea that he should become an artist was still so much pie in the sky. Also, I would think, in an age when British troops were still in action almost every day in some corner of the world, more small boys than usual saw themselves as future heroic soldiers. Ernest Shepard never misses an opportunity to mention uniforms or weapons, and in him that old ambition seems to have struck deeply.

There is one passage in this book that describes elder brother Cyril, who collected South African stamps, being shown by his father an old letter from the children's uncle, their mother's brother. This uncle had long been settled in the Cape and volunteered for service in the Boer War of 1880. Drafted into transport, he was put in charge of a bullock wagon. 'In the very early hours of one morning they were at the foot of a steep hill, Majuba Hill. The infantry had orders to climb this, and led by their General, they did so before it was light. Their action surprised the Boers, who, however, reacted quickly and counter-attacked them. Creeping close under cover of the rocks they picked off our men by their good marksmanship. Finally only a few of our men were left and the order was given to retire. As they fell back, the men started to run. Down the steep hill they came, as fast as they could, many, including the General, being shot on the way. We pored over this letter with the deepest concern, as we could not bring ourselves to believe that English soldiers *ever* ran away. I certainly did not believe it and would not admit of any doubts; after all, I had the evidence of the stories I had read in the *Boy's Own Paper* or *Heroes of Britain* to support me. I asked Mother what was her opinion. She thought that what our uncle had written was right, but that he might have exaggerated.

Martha, the faithful nurse,
teaching the children Methodist hymns.

Having seen a Professor Baldwin make a parachute descent
inside the Crystal Palace, Ernest and brother Cyril experimented
at home with sister Ethel's dolls.

'Then, one evening when I was going to bed, I tackled Martha, [nurse; Lizzie was by now cook] about it. Toothbrush in mouth, I put forward my views, but she, a staunch chapel-goer, had no sympathy with wars or with fighting in any form. I could get no answer from her; in fact she told me I was wicked to think about such things. This was to me a new and disturbing point of view, but I knew that Martha had very strict ideas of what was right and proper. Honest as the day, she entertained no compromise – things were right or wrong. A Primitive Methodist from the Welsh borders, she loved to talk of the chapel to us children, or to sing us the hymn tunes that she herself had learnt as a child. Sitting by the fire in the nursery, or later in the playroom, she would sing the simple Methodist hymns to us, while Cyril was poring over his beloved stamps and I, perhaps, was drawing in my copy-book. Ethel learned to play some of these hymns on the piano; she was quick at picking up tunes, and our little piping voices would sing them together.

> *When He cometh, when He cometh*
> *To make up His Jewels,*
> *All His Jewels, precious Jewels,*
> *Bright gems of His crown.*

'Twenty-nine years later I was to hear the words of those hymn tunes again. They were sung by Welsh voices on a dusty shell-torn road in Picardy, as a battalion of Welch Fusiliers marched into battle. I was standing by the roadside, close to what had been Fricourt, when they passed. I was grateful for their song. It seemed as if the men were singing a requiem. For that day I had found my dear brother's grave in Mansell Copse. The spot was marked by simple wooden crosses bearing the names of the Fallen roughly printed on them. It was, and is still, the resting place of over two hundred men of the Devons who fell that Sunday morning in July 1916.

'They will shine like the Morning'

The illustration of soldiers retreating is the only one in the book that pictures a mental reaction. All other drawings are of childhood scenes as a child viewed them. But here is a child thinking and a man remembering. Ernest Shepard was not a person to show emotion, however heartfelt. All his family agree about that. 'A very private man', wrote one of his obituarists. That combination of war and his brother's death brought from him a very rare overflow of grief – and he had suffered many other sorrows by the time he wrote this book. In a small old wartime sketch-book of his there is a rough drawing of that cemetery at

Finding money for Mother's present.

All the children were made to play the violin.
And Ernest gained a love of music that he never lost.

Mansell Copse, five of the plain crosses beneath some shell-ripped trees. 'Old Front Line of July 1st, 1916. Cyril's grave.' Like a good gunner he has marked in the directions of Fricourt and Marnety Wood. Ernest Shepard did not reproduce the sketch in *Drawn From Memory*, and therefore I do not do so here.

The Shepards remained in Kent Terrace, where Ernest felt he spent the happiest years of his boyhood, for nearly seven years – until 1890. With Regent's Park behind, and not *too* long a walk across that to the Zoo, it was a pleasant enough place to be, and indeed an even 'better address' than Henry and Jessie had occupied before. They must again have made the move to gain more space, for the children were becoming inventively boisterous. 'The front dining-room was separated by folding doors from the smaller back part, which we used as a playroom . . . The hall was paved with tiles and the staircase was of stone with iron banisters. It was wide, and open enough for us to play our favourite game of parachute descents. This pastime had been a craze with Cyril and me ever since we had been taken to the Crystal Palace and seen a certain Professor Baldwin make the perilous descent from the main transept.' They did not, in Kent Terrace, attempt the drop themselves but used Ethel's old dolls, tied to handkerchiefs, after an umbrella descent had failed ('the casualty rate was high'). Ethel, by two years the eldest (another two years separated the boys) was, fortunately, becoming disdainful about dolls. She went to a Church of England High School in Upper Baker Street, while the boys went to an attached kindergarten behind it in Allsop Place, whence they could look over a wall and watch the trains steaming in and out of Baker Street Station. Altogether, with Martha and Lizzie to look after the house, Henry and Jessie Shepard had quite an establishment to cater for.

At home all three children studied the violin, with lessons once a week from a Mr Cruft. ('It was dreadfully tedious having to play scales, and my fingers never seemed to be in the right place, but it was better when I was promoted to Boccherini's *Minuet*'). Mr Cruft at any rate cannot have been dull, for Ernest Shepard entertained a real passion for music throughout his life.

There was a small garden running between Park Road and the front of the terraced houses, accessible to tenants with a large and rusty key, and there the children found they could play undisturbed. Park Road was inviting enough, with its wide pavements, running from Baker Street Station to St John's Wood Church and Lord's Cricket Ground.

From the Shepard's Kent Terrace home,
the Zoo was only just across Regent's Park.

Park Road, St John's Wood,
with the Windsor Castle pub flying a light blue flag
to signal a Cambridge victory on Boat Race Day.

Some of the shops that Ernest describes, including the 'Victoria Wining Shop' (as Martha called it; she had a friend working there, and took the children to call), existed at least until the second world war. But it is a long time since the tradesmen all called round by cart or on foot, or since the Windsor Castle, a pub of great repute, flew a light or dark blue flag on Boat Race Day to signal whether Cambridge or Oxford had won.

In 1890 Jessie Shepard died. She had been ill for some time, and the children had come to accept that; but without any idea that she might leave them. Ernest was ten and, naturally, shattered. 'The shock of Mother's death went much deeper than I realized at the time. By temperament I was a resiliently happy child, but this event left a scar for years.' (It was not until writing about his second year at the Royal Academy Schools, when he was eighteen, that he was able to say, after a holiday with friends in Devon: 'My visit to Devon had a profound effect on me. It seemed to open a new chapter in my life. Much of the happiness that I had felt when Mother was alive returned to me').

The success of *Drawn from Memory* encouraged Ernest Shepard to write a second collection of remembrances in 1961. This he called *Drawn from Life*, and it took his youthful progress from his mother's death to his marriage in 1904, moving again in fits and starts. It is a more restrained piece of work, and was less successful. That when he wrote it he was four years older (and between seventy-eight and eighty-two they are long years), that they were not the tales, as the earlier ones had been, for which his children had provided so enthusiastic an audience, that his second wife, Norah, was looking somewhat sternly over his shoulder as he worked (having seen the first book only after it was finished) – any of these rubs may have inhibited him. True, when he saw Cissy Loftus in Cinderella at the Crystal Palace (he was twelve now) he remarks that 'no male boy ever had such lovely legs!' And he cut her photograph from the programme and kept it for years. But there is no smacking reminiscence about thighs. Back again at the Drury Lane Pantomime when he was sixteen he cannot even remember the name of it, nor of the principal boy. 'I am sure,' he writes gallantly, but lamely for him, 'she was quite as ravishing as the "Boy" I had seen seven years before. I did not suffer the pangs of unrequited love on this occasion; surely a warning sign of advancing age . . .' Either that, or of a more self-conscious author.

Nevertheless, *Drawn From Life* is again interesting as a comment on an age, and gives us our only knowledge of what Ernest Shepard and his

father were up to. So often in Victorian recollection the veil drawn over
the indecent matter of the bank account obscures the reasons for sudden
ups and downs of fortunes. Henry would have been an odd father for
his time if he had told his children how well or poorly he was doing,
financially, nor would the children have dreamed of asking. After their
mother died they were too young and shocked to realise that there was a
very lean period. It may have been that old William Lee had made some
settlement on his daughter that ceased when she died, or simply that
she and Henry had overreached themselves in moving, always for the
better, around St John's Wood. The immediate result of Jessie's death
was that the whole family moved out of Kent Terrace and went to live
with the aunts in Gordon Square. Of course the distraught Henry had
to find someone to look after the children, and the willing aunts were
the obvious answer. But there is evidence that there was not much
money to spare. There is no more talk of the office at Great Marlborough
Street, and Henry is described now, more than a little vaguely, as
'architect and adviser' to University College Hospital. He rented 'for
convenience' a small studio in Gower Street which he later shared with
an artist, E.F. Brewtnall, described by Ernest as 'quite as hard-up as
Father', but a good tenant. The family lived for nearly a year at the
aunts – and it must have been a most depressing period, though Ernest,
typically, manages to make light of it – until one day Henry told the
children that 'he had decided we must have a home of our own. He had
been looking for a house, something he could afford to rent, and had
found one in Hammersmith.' He had in fact found No 2, Teresa Ter-
race, a little Georgian brick house with a pleasant garden at the back;
and a studio. 'Moreover, the rent was only fifty pounds a year, an im-
portant point, since Father's finances were in a bad way.' It seems Henry
had also decided his children were old enough to know about money.

Henry Shepard was pleased with the house he had found in Hammer-
smith – three storeys and a basement with area railings; a wide, square
front door with a fanlight, a stone-flagged hall and a nice little garden at
the back with a studio. It had been occupied by an old artist and his wife
who were sad to have to move, for it was set among a colony of artists.
The engraver Stacpoole lived next door, and nearby were George
Mason, Gleason White and W.B. Richmond, then all names for a young
would-be artist to respect. Ernest Shepard recalled the house, destroyed
long before he wrote of it, with his quick, retentive vision. 'The
drawing-room mantelpiece and its sides were fluted white marble. A
medallion at each corner had a lotus pattern in the centre.' His father
told him that it was a fine example of Georgian work. 'Another thing

that pleased him was a pair of tall mahogany bookcases built into re-
cesses flanking the fireplace. Being an architect, Father naturally valued
such things. It was a great many years before I came to appreciate them
too. These bookcases, saved from the house-breakers when the house
was demolished, now ornament my own drawing-room.' (Ernest
Shepard was writing in 1960 from Woodmancote, his home in Lods-
worth, Sussex).

The decision to move to Hammersmith had been taken, though at first
the children did not know it, because their father had managed to enter
the two boys for St Paul's, almost certainly arranging for reduced fees
through brother Willie, by then quite a senior master at the school.
Cyril and Ernest were at a preparatory establishment in Acacia Road
St John's Wood. It was called 'Oliver's', after one of the two joint
headmasters, and the brothers heartily loathed it. 'Our days were spent
in trying to avoid punishment,' which could come either from the
masters, or bullying schoolmates or, on the way home, from hostile
local errand boys. 'I do not remember learning anything at Oliver's
beyond an apprenticeship in self-preservation.' This was not simply the
case of being a lonely misfit (indeed it would be hard to think of Ernest
Shepard being a misfit anywhere). 'Years afterwards, when I was a
student at the Royal Academy Schools, the student at the next easel was
Denis Eden, who had been at Oliver's with me . . . He turned to me one
day and said in a low voice, "Shepard do you ever wake up in the
morning with a feeling that you have to go back to that place?"
I am sure it had a blighting effect on both our young lives.'

Ernest, however, survived the blight, and the news that he and Cyril
were to go to Bewsher's, the prep school for St Paul's, came as a joyous
reprieve. It seemed that the escape from Oliver's, coinciding with
experience of a totally fresh new atmosphere at Teresa Terrace, where
he enchantedly watched the slow process of redecoration, worked on
Ernest Shepard to make him consider seriously a future as an artist. He
was still not much more than a child, and as a child the idea had been an
amiable dream. Certainly his mother had never ceased to encourage it,
and 'though she had little talent herself, would show me how to use my
paints'. With his mother he made plans for life as an artist when he grew
up – 'she, almost more than my father, encouraged me to persevere' –
but they could hardly be more than nursery enthusiasms.

Now, at Teresa Terrace, he found himself surrounded by people who
talked art as naturally as other people might talk pleasure, or politics or

Oliver's School: the entrance way that always struck gloom into Ernest.

business. 'After church we would walk back with the Calthrops, who were old friends of Father's. Claude Calthrop, an outstanding painter, who had barely reached middle age, had died recently leaving a wife and two children, Everard and Hope.' And Everard's cousin Clayton was often there; he was the son of the actor John Clayton and of Nina Boucicault, and was studying at St John's Wood Art School. 'He asked me if I wanted to be an artist. When I said yes, he told me that it was a precarious life and badly paid, but all the same he was going in for it and it was jolly well worth while.' Everard had been studying the new French Impressionists, who were despised by some of Henry Shepard's artist friends. 'But Frank Dicksee, with all his academic training and in spite of being a Royal Academican, never spoke in such terms and was far more catholic in his tastes.' It was years before Ernest himself was to understand the Impressionists, 'years spent in painstaking study of the antique, a cautious introduction to painting'. In his father's Gower Street studio there was a plaster cast of the Venus de Milo, which Ernest strove to copy again and again in his first attempts on classic art. He still sometimes sat for Frank Dicksee in his studio at Peel Street, near Holland Park, and Dicksee allowed him to try working in oils on a canvas board. 'I would quickly get into trouble but dabbled on quite content, and feeling I was being a real artist.' He was still not yet twelve years old.

He talked art with his father's friends, but he was still fascinated that Everard Calthrop, who had left the senior school at St Paul's before Ernest entered it, was at Woolwich, 'learning to be a Gunner at the "Shop".' Ernest notes that Everard, an extremely clever draughtsman, must have met success as an artist, but instead 'made a brilliant career in artillery, where he made a special study of Eastern warfare'. Always there is that admiration for, the hankering after, the military. In *Drawn From Life*, as in his previous book of memories, almost the only comment from hindsight concerns war and men at war. Writing of two boys he met and got to know at St Paul's – both of whom became regular officers and were killed with their battalions in 1915 – he says: 'How glad they would have been to know that, fifty years later, plans for the greatest military operation of all time were to be made by an Old Pauline in this same building'. (A reference to Field-Marshal Montgomery preparing for World War II's D-Day, using St Paul's School as headquarters). Contrast this to finding himself in the same class at Bewsher's with 'my particular friend,' William Temple, son of the then Bishop of London. 'I think he was always keen to follow his father into the Church.' Indeed he was, and he became Archbishop of Canterbury,

First attempts to copy classical
art were made with the help of a plaster cast of Venus de Milo,
which was in his father's Gower Street studio.

which Ernest Shepard doesn't bother to mention. And, also at
Bewsher's, reporting a football match in the best laconic style of any
schoolboy letter: 'I played back with Douglas Home.' (Uncle of Sir
Alec Douglas-Home who was Foreign Secretary when Shepard wrote
the book, and shortly to be Prime Minister). But anything martial
always lifts the spirit. Visiting the Dicksee house, which was near a
Volunteer barracks, 'I decided that if I could not be a soldier, I might
at least be a Volunteer'. In Rouen, when his father first took him to
France, 'what particularly pleased me was the number of soldiers
about . . .' In the summer holiday after he left St Paul's he spent a
whole day in Hampshire following infantry manoeuvres, men
'storming up-hill, in the Inkerman style'.

Queen Victoria's Diamond Jubilee was one long, exciting military
parade. And when he was introduced by a girl art student friend to
Baden Powell (with the understatement of the century: 'This young
artist is very keen on soldiers') he says it was the greatest thrill of his
young life. Yet even after talking to and admiring Everard Calthrop,
Ernest did not want to become a soldier simply for the sake of soldier-
ing. There had to be a reason why. When the first chance came, with the
start of the Boer War in 1899, he was at the Royal Academy Schools,

and there was now no certitude that right was always on the British
side. There were hot arguments among the students. 'In spite of my
love of soldiering I could not work up any enthusiasm and never felt
the slightest impulse to volunteer for the Imperial Yeomanry.'

Ernest enjoyed himself both at Bewsher's and later in St Paul's School
proper. He made friends, he played games enthusiastically, and he
worked well, first on history and English and then at science. And 'two
mornings a week we worked in drawing school'. Ernest was extremely
lucky in having had St Paul's, by force of circumstance, chosen for him.
Under an excellent 'High Master'* it was going through a very success-
ful period, and much attention was paid to the special aptitudes of the
boys. Ernest was only two and a half years in the senior school, but the
last of them was spent very largely in the Special Drawing Class (of
which, at one time, he was the only member), after the High Master
decided he was cut out for a scholarship at the Royal Academy Schools.

The art school was intelligently run, due mainly to the versatility of
the two assistant masters, brothers named Holden, and collected pupils
with special gifts from various forms, including – to Ernest's satisfac-
tion – the Army Class. 'The art school was the place where the great and
the small came in contact. It was there that I saw G.K. Chesterton and
Compton Mackenzie (he was 'Compton' then).' Quite early on Ernest's
obvious talent singled him out for special treatment in art instruction.
'What pleased me most was the encouragement I was given to put my
own visual thoughts on paper. I drew every sort of subject, with a pref-
erence for battle scenes, and I usually produced one or two by way of
homework.' His time was so taken up with drawing that he gave up
studying the violin, the instrument on which he had faithfully been
taking lessons ever since those early days in York Terrace. But he did not
abandon it in boredom or despair; his love of music remained as strong
as ever. 'It was during my last year at St Paul's that I began to take a real
interest in music. Ethel, by now an accomplished pianist, would play
Bach to me by the hour . . . She would painstakingly try to explain that
fugues did not depend upon tunes, but it was many years before I under-
stood what she meant, and I was always relieved when she turned to
Chopin.' His sister had studied at Queen's College, Harley Street, and
taken piano lessons at London Academy.

Somewhere or somehow Henry Shepard's finances picked up a little.
The boys only knew this because at the beginning of Ernest's second
year at St Paul's (January 1895) they were given rather more pocket

*Fred W. Walker. Ernest only refers to him as 'The Old Man'.

The business of moving house again.
The Shepards were off to Hammersmith (1891).

money. They had just spent the best summer holiday they had had for
years at Shalford, just south of Guildford, where the Aunts had rented a
vicarage for the season; their cousins had, simultaneously, taken a
house at Guildown, where Ernest's Shepard grandfather had built
his country seat, and the two families could reach one another by ferry
across the river Wey at St Catherine's Church. When they returned to
school, thoroughly elated, the brothers spent their extra allowance at
the theatre and music hall. They did not tell their father that they went
to the music hall because he disapproved of it, despite his keen interest
in the stage. 'No doubt this was due to his upbringing, for my grand-
father's views on all things theatrical, even the legitimate stage, were
extreme, and my aunts were never allowed to go to the theatre.' Ernest
still knew the feel of the shadows thrown by that house on Gordon
Square.

Cyril left St Paul's at seventeen to become a clerk at Lloyd's in the
city, presumably sponsored by Uncle Robert. That was in the summer
of 1895, when Ernest still had a year to do at school. They had holidays
at Eastbourne where the Aunts, whose choice of summer houses was
certainly catholic, had rented a girl's school. The whole top dormitory
floor was closed off, but the gymnasium was open downstairs and Ernest
'spent hours climbing ropes and swinging on rings'. Cyril could only
get a strict two weeks off, and that, in Ernest's eyes, was hardly compen-
sated for by the status of 'city gent' and the buying of a bowler hat.
Henry Shepard appeared briefly and took his sons across the downs for
lengthy walks, during one of which he explored a derelict building hid-
den in a 'jungle of weeds' and discovered the clergy house at Alfriston,
now restored and a protected monument. Cyril's last morning came all
too soon, and the boys got up early for a final game of tennis. But 'the
dew on the grass made the balls too wet. As a result we had to run nearly
all the way to the station. After his departure I missed him terribly.
The Aunts did not seem to understand we needed companionship of our
own age.' The brothers were very close. St Paul's next term had lost
much of its interest for Ernest, and 1895-6 was a long, bitterly cold
winter. He tells us little more about life at school.

During Ernest's last term at St Paul's he was already working on
Saturdays at Heatherley's Art School, chosen by his father who had
once attended evening classes there. At Heatherley's he was to make
his final preparation for an attempt on a scholarship to the Royal
Academy Schools. The building was in Newman Street, off Oxford
Street not far from Tottenham Court Road, and was properly ancient,

Ernest's impression of a Crystal Palace audience (aged about 14).

'Drawn for my homework, age 15'.

having been used by Thackeray as his original for 'Gandishes' in *The Newcomes*. You passed through the house and down three steps to the Antique School, which was cluttered with plaster statues. Beyond was the Costume Studio with its model's throne and its wardrobe. The choice of costumes was extensive, but too often arranged for the convenience of the flock of elderly ladies who were more or less permanent students, and for whom the vogue in would-be Academy pictures was cavaliers and pirates.

After another summer holiday (1896) with the Aunts – this time at a mansion in Hampshire – Ernest began regular work among the time-tattered surroundings of Heatherley's. He was a small sixteen, and felt very strange alongside the mixed bag of students, 'some of them grown men with beards', even stranger to find himself addressed as 'Mr Shepard' by the dignified, frock-coated principal, John Crompton, whose criticisms of drawing were always phrased in the plural. ('If we look at our legs, Mr Shepard, I think we shall find them a trifle on the heavy side.') Most of Ernest's time was spent drawing from the antique and he was disappointed. 'I was not encouraged to do any painting, and never learned anything of construction or design. The tuition was not good and I often think I should have done better to have gone to the Slade where, under Tonks, more attention was paid to good drawing and less to stippled finish.' However, he had to stick at it, for he had the Royal Academy Schools' scholarship in view – and only a year ahead. Luckily, he gained encouraging help from seeing some drawings by George Stampa, who had won the same scholarship the year before. 'I looked at his drawings with awe . . . George himself was, however, most reassuring.' True to curious form, Ernest does not mention the fact that afterwards, for many, many years, George Stampa was his friend and colleague on *Punch*. Later that autumn, four or five of the young students, having got to know one another, started going around as a regular group, lunching together at 'Buck's' in Oxford Street, and discussing the woes of their own penury. Life at Heatherley's became fun. Ernest could give vent to the gaiety that always chuckled inside him – indeed, I suspect, never left him, though it had to be bottled up in later years according to the conventions of respectable success. At Heatherley's he first became known as Kipper, the name by which family and friends knew him ever after. 'I think I earned it by somewhat gay and irresponsible behaviour, the expression 'Giddy Kipper' being a music-hall catch-phrase at that time. Anyway it has stuck to me ever since, though usually shortened to 'Kip'.'

Hockey as played in the Royal Academy Art Schools.

Nobody who was actually in London in 1897 for Queen Victoria's
Diamond Jubilee ever seemed to have forgotten a minute of it. Ernest
Shepard was willing to talk of it as long as anyone would let him. In
Punch circles, forty years on, he was only upstaged by that gentle writer
of romantic light verse, 'Dum-Dum', otherwise Major Guy Kendall,
who as a subaltern was among the troops lining the streets as the royal
procession passed by. The day was June 22, but the capital had caught
the fever well before spring, when Ernest bicycled round inspecting the
stands being hammered together and the camps being prepared in the
parks to lodge the inflow of troops. To add to the excitement for the
Shepards, Henry, who had given up the amateur theatre after his wife's
death, was asked to play Malvolio in a special open air performance of
Twelfth Night in private gardens in Richmond. Cyril and Ernest were
given small parts. But Ernest still had to get his drawings ready for the
scholarship examination. The little gang of young students had broken
up – most of them had gone to study elsewhere. It was, perhaps, just as
well. 'In spite of all the excitement I managed to get on with my
drawing . . .'

On the big day the Shepards were up at 5 a.m. They and the Dicksees
had hired a room over a butcher's shop in Westminster Bridge Road,
right on the route the procession would follow through south London,
on its return after the Thanksgiving Service at St Paul's. The eyrie
might have been specially chosen for Ernest, as it turned out to be bang
opposite the old Canterbury Music Hall. Its windows were all occupied
by variety stars who gave the waiting public a riotous free show, and
who led what was Ernest's first experience of mass singing. They had
a long wait for the Queen, but the last soldier had passed by 2 p.m., and
the Shepards and the Dicksees took a long time struggling home after
that. Cyril and Ernest were determined to go out again after their tea to
see the illuminations. But first, 'Father insisted, most wisely, that we
went upstairs to lie down' and this they dutifully did. Victorian fathers
had a wonderful way with boys of twenty and eighteen.

Not long after Jubilee Day the Royal Academy informed Ernest that
the Schools had accepted him on probation as a student, subject to his
attending, with drawing materials, for a further examination. That in-
curred a further fortnight's work at the Schools. There were seven
other aspirants with him, and in the end they all passed – which meant
three year's free tuition. Ernest thought his father was pleased. He must
in fact have been most mightily relieved. It was proving a wonderful
Jubilee year for Ernest, and there was more manna to come, from that

Ernest's father, Henry Shepard, a keen amateur actor,
as Malvolio in a special performance of *Twelfth Night*
during Queen Victoria's Diamond Jubilee Year.

most unlikely of heavens, the house in Gordon Square. Two of the four
aunts who had lived there had died in the past year, and the survivors,
Alicia and Fanny, had not the heart to rent a house just for themselves
in the summer. That, they knew, would mean no holiday headquarters
for Henry and his family, and they suggested instead that he should take
the children to France; they would help pay the fares. Anything that
had ever been said about the aunts being stuffy old bores was instantly
retracted. Thank you letters were immediately written without protest,
and Ethel indeed went off to Gordon Square to pay her grateful
respects in person.

Henry had always been promising to take his children to France.
He had frequently been over himself on painting expeditions, mostly to
Normandy, so that he knew the country well and was able to make it
warmly enjoyable both to Ethel, who knew French fairly well, and to
her brothers who did not. They travelled to Varengeville, near Dieppe,
and to Rouen and to Les Andelys, and they were wonder-struck with
the surprise and delight that the young always meet when they first go
abroad. Ernest was enchanted, and from his first visit welled a great love
of France that was another passion which stayed with him for life.
After a fortnight they travelled home content, Ernest making a pillow
of his coat on the deck of the paddle-steamer *Rouen* and thinking, in the
wakeful moments of that night, of his future life as a painter in the
Royal Academy Schools.

The Hotel du Grand Cerfs, Les Andelys,
where the Shepards went on their first family holiday
in France (1897).

1897-1914

The making of an artist

1 Willingly to work and marriage

Kipper, as he was known to so many, entered the Royal Academy Schools in 1897. That summer the family learned that Teresa Terrace was to be pulled down to make way for a row of shops, and Henry, who said that Hammersmith had been giving him rheumatism anyway, found another house in Shooters Hill Road, Blackheath. Neither Cyril nor Kipper was very keen on it, largely because of the long distance they would have to travel daily to London, but their father bought the lease (he must have had some funds at the time). They moved in the autumn of 1898.

In his second year at the Schools Kipper, without telling his father, entered three works for the Landseer Scholarship – a study of a head, a painting of a nude, and a drawing. He won the scholarship which was worth £40 a year for two years. ('Forty pounds for two years seemed to me a fortune'). He went off with Ethel, proudly paying his own fare, for a visit to friends in Devon (it was the time he said he regained the happiness he had lost when his mother died); and when he returned his father ('I think he must have had a windfall') offered all three 'children' a holiday in Germany. Meanwhile, at the Schools, he was occasionally meeting Florence Chaplin – not such an easy matter because men and women neither worked nor lunched together as they had at Heatherley's. She was one of the cleverer students, a granddaughter of Ebenezer Landells, artist and one of the founders of *Punch*, and three years older than Kipper. The Chaplins were a large family and when Kipper got to know Florence better he used to visit them together with Cyril, who became a great friend of her sister, Adrienne (Addie).

In the summer of 1900 Kipper won the British Institution Prize, which carried £60 a year for two years, so that in twelve months of 1899–1900 he earned the princely sum of £100 in prize money alone, while he scratched up a few pounds by drawing jokes for such magazines as *British Boys* at five shillings a time. He was already trying, unsuccessfully, for *Punch*. At the end of the year 1900, just after his twenty-first birthday, he rented, with a fellow student, a studio in Glebe Place, Chelsea, and felt that at last he had set up as an artist. There were distractions, though. His father, though now badly hampered by arthritis, had agreed to stage *Measure for Measure* in aid of sick children at Great Ormonde Street Hospital, and both Kipper and Cyril had small parts, Kipper also enlisting numerous art students for the crowd and dance scenes. He had grown a lot in the last year, and it was no longer necessary for Florence to introduce him (as she did when he first met her family) with 'This is little Shepard'. He took the lead part in a burlesque of *Sherlock Holmes* a

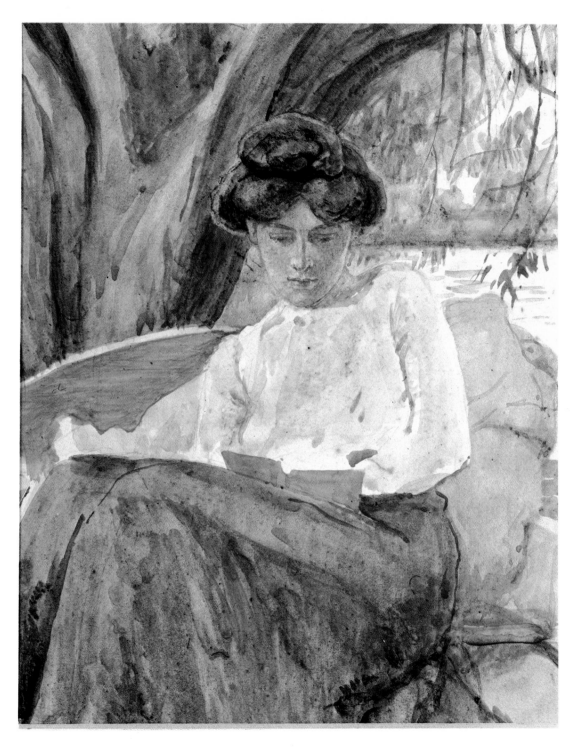

Florence Shepard (née Chaplin):
an early water colour of his wife by Shepard.

little later. Nevertheless, although still a student, he had two pictures accepted for the Royal Academy's Summer Exhibition in 1901, and one of them, a portrait of Ethel, hung on the line ('the only success I ever had with a portrait').

Kipper's Landseer scholarship had ended and he no longer had to attend the Schools regularly (which had been a condition of the grant). It was just as well, because he had to spend more and more time at Blackheath looking after his father, whose illness now gripped him so badly that he could hardly walk. Florence came down to see them, and Kipper felt that his father was very pleased ('I think he hoped we might become engaged'). Henry's doctor advised consultation with a specialist, and after a dreaded trip to London the worst was known; it was disseminated sclerosis and there was no hope of a cure. Henry talked of taking a sea voyage, but when Cyril and Kipper were at last allowed to look at his finances of course they found there were hardly any funds left. Instead they took him to Dover for a week, pushing his wheel-chair along the sea front against cold and blustering winds. Henry lasted manfully through that winter, but died at the end of the following May (1902).

'The illness had cost a lot of money and there was hardly anything left. Cyril and I had a difficult interview with the bank manager, who pointed out that our best course – indeed our only course – was to sell the lease of our house.' So they sold, and stored the furniture, and moved into rooms in Hyde Vale, near the Black Heath itself. Ethel started to work in a bank. Kipper could no longer afford the studio, but fortunately the agreement had not long to run. He was painting a picture for Morden College Chapel and Florence was doing a mural for Guy's Hospital, and it was at this point, with no prospects but the work they had in hand at the moment, that the pair decided they loved each other and would get married. Kipper realised that he must 'tout round for some more black and white,' but he went on painting in oils as well, especially landscapes. They worked on, as steadily as employment allowed, for the next two years, and then in 1904 made their engagement official; they would get married in two months. Their news was generally welcomed by the two affectionate families, but drew such a classic blast of antic condemnation from Uncle Willie, the master at St Paul's, who presumably considered himself *in loco parentis*, that his letter to Kipper is worth quoting at length.

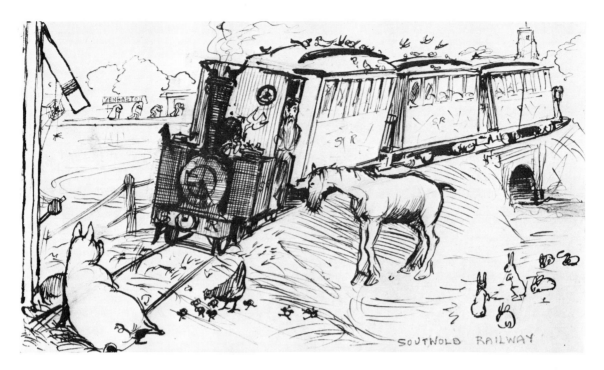

The Chaplins had a house near Southwold, in Suffolk,
that Shepard used to visit when he became engaged.
The Southwold Railway remained a joke for many years.

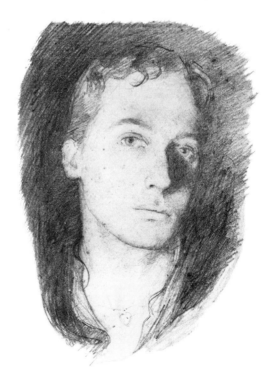

Ernest Shepard; a self-portrait
drawn while he was at the Royal Academy Schools.

'You frankly admit.' wrote Uncle Willie, 'that your decision to marry in about two months "seems rather rash". But you appear to have made up your minds that the rashness of taking such a serious step is outweighed by other considerations. It is, of course, quite natural that you and Miss Chaplin should hope for the best, and should feel confident that the usual consequences of "marrying in haste" which generally means marrying without the certainty of a sufficient income – will, in your particular case, fail to appear to declare themselves. But is this truth well founded? Rashness is regularly followed by its appropriate consequences, and knowledge that this is so usually comes too late.

'It is very disagreeable to me to appear to throw cold water on your vision of love in a cottage etc. etc. If I could honestly do so, I would much rather indulge in the language of encouragement and good cheer. But between the young and the old there is this important difference, that the former have hopes and visions, while the latter have a hoard of experience, by which they are guided in deciding for themselves, and in in giving counsel to others.

'We all learn by what we experience, either of good or ill. The real failures in life are those who trust to luck or the chapter of accidents rather than accept experience as their guide.' He goes on to say that young people 'in our rank of life' who marry on less than £250 a year are taking a 'perilous risk'. He himself started on £380 a year and a house with all rates and taxes paid, and even so 'Bessie and I did not find it fully adequate'. A few young schoolmasters he knew had married on £250, 'and I know that in these cases their life was a terrible struggle to keep up appearances, and involved the necessity of the wife becoming a household drudge. These are the grim facts that have to be faced. And another fact is that Poverty is the milieu in which Art seldom thrives.' After that fine peroration he signed off: 'With our love to you all, ever your affectionate Uncle.' It should be said that having done his duty, and after discovering the optimistic temper of the rest of the family, he turned up at the wedding in great form and presented the happy couple with a cheque for £25.

It was in fact love in Arden Cottage, at Shamley Green in Surrey. Kipper was not impressed when he first saw the place. It was empty, and a local gardener named Foxall had the key. The cottage 'was very small and square with a porch in front and no architectural pretensions. The roof was of slate and the overgrown garden had a railing with a gate on to the road . . . The kitchen, on the left, had a

A lovely Shepard oil of Florence, also displaying 'The Suffolk
Press'. This piece of furniture, a gift of her mother and the
couple's prize wedding present was made about 1800 and Florence is
dressed to echo the period.

brick floor, a decent-looking range, and a box staircase leading up-
stairs. A sitting-room on the right smelt of damp and the paper was
peeling off the walls. There was a scullery with a pump at the back and
a sort of larder beyond. Upstairs were two bedrooms with fireplaces and
a tiny room under the eaves behind. The windows were iron framed
leaded lights.' Foxall told him that the well water was no good, mostly
surface drainage, and that the sanitary arrangement were in a shed
outside. He relented enough to tell Kipper that he could always draw
good water from a neighbour whose well never failed. There was, of
course, no bathroom. However the cottage did have the advantage that
the rent, after the somewhat casual landlady had written out a brief
agreement on a single sheet of paper, was £6 a year. And the local
builder's estimate to make the place liveable in was under £16. Cyril and
Ethel came down to clear up cottage and garden after the builders had
finished, and Kipper and Florence had their first home. They lived there
five years (never seeing the ghost which was supposed to haunt it) and
their son Graham was born there.

Two years later, in 1909 before their daughter Mary was born, even
Kipper and Florence realised they would need more room, and they
moved within the village to Red Cottage, Holbrook Lane. It could have
been a semi (with bow), in a suburban street, Mary remembers, 'but it
was built on the site of something more rural where someone a long
time ago planted an orchard. The front porch was embowered in roses
and to the eaves there was a thick growth of ivy, and someone else had
planted a hop and a vinegar grape on the south-east corner. Inside, the
rooms were small. A short staircase led from a dark hallway to four bed-
rooms (and offices), and below were two living rooms and the kitchen
and larder. The kitchen had a coal range with a hot water tank and a
hand-pump over the sink, with half an hour's work a day to fill the
tank. This was my father's task. A dresser stood along one wall on
which stood or hung willow-pattern plates and cups, and outside the
kitchen, tacked on, was a downstairs closet, with flush.' There was also
a free-standing studio, near what 'the ancient odd-jobbing gardener
called the Carriage Drive,' and a sizeable garden with lawn, and good,
old trees, and flower and vegetable beds. It was a palace compared to
Arden.

Kipper and Florence quickly became part of the village life in Shamley
Green, for they made friends easily. The Gossages, for instance, who
were pillars of both local society and church, became so intimate as to
become benefactors. Later when Graham and Mary went away to

A sketch done in 1909.

'The Royal Cape Colony Mounted Tailtwisters,
before leaving for the Front' –
is Shepard's own caption for this mock group.

boarding schools they for a time paid the fees. (It was indeed generous, but not perhaps pure generosity. Mr Gossage both liked Kipper's work and saw its possible future value. Many of the chalk sketches Kipper did in France during World War I were bought by Mr Gossage, and Kipper is unlikely to have charged him very highly). There was plenty of social life in Shamley Green, and again there was acting. Kipper stage-managed a *Midsummer Night's Dream* in the garden of Long Acre, the house next door, and played Bottom as well. And in between it all, together or independently, they still managed to travel – up, down and across the country, visiting friends and relations or fulfilling commissions. Though Florence was kept more at home after the babies came, to read their letters you would think they were forever apart. For they wrote, how they wrote letters! If either of them were only away for a day, there would be a letter posted that night to arrive at home in Shamley Green before he or she did. And in all that correspondence it is hard to find word of pique or of complaint. There is, incidentially a passage in *Drawn from Life*, in which Kipper explains to Florence how and why he came by his nickname, and she confesses that her father started the family calling her 'Pie' when she was a chubby infant; and they agree to use each other's pet names. But in their innumerable letters he addresses her as 'Mont', and she him as 'Kits', for reasons Kipper never explained.

Obviously, by 1910 or '11, despite the cares of a new family, Kipper was doing better; equally obviously he was working very hard indeed – something that had never worried him. But it was not a time when anyone could look ahead with unshadowed optimism, not even the benign Kipper. Perhaps one should say especially Kipper, for he had seen, at an impressionable age, both France and Germany; also he felt he knew what war was about.

Sketch for dust-cover of book which may or may not have been published. There are several such roughs among Shepard's papers of the early 1900's, when he was after any work he could get.

2 The development of the line

by *Penelope Fitzgerald*

Penelope Fitzgerald,
Ernest Shepard's step-granddaughter,
is the author of 'Edward Burne-Jones: a biography'
and 'The Knox Brothers'.

Kipper enjoyed working in oils. He used to take them out and put away his watercolours with a sigh of relief at the sensation of freedom. But in the remark which he often made, that he and his friends had set out to earn their living as painters and finished as illustrators, there was not the slightest touch of bitterness. He was, above all, a professional.

Kipper entered the Royal Academy Schools in July 1897, receiving his ivory ticket with the number 4570, and shown in the records as very much the youngest student there. Admission at that period meant 'producing required specimens of ability', which included a finished drawing in chalk not less than two foot high of an undraped Antique Statue, and the working day was a long one, with two hours of drawing classes beginning at 6 p.m., when the daylight began to fail. Entry for the various medals and competitions, which were designed to keep the students hard at it, were forbidden to those who had not attended the lectures. Although the Schools had been altered and enlarged ten years earlier at the cost of £25,000, the ventilation was still not quite right, and students and models alike were said to faint because of the 'heat and impurity of the air'. No student was permitted to speak to a model within the walls of the Royal Academy, men and women never worked together, and once the model was set no-one was allowed to approach or to suggest a different position.

Yet there was a sort of cheerful freedom about the place, and for Kipper, who was sociable rather than bohemian, the celebrated Rules of Behaviour cast no shadow.

As you went into the Schools behind Burlington House a gust of warmth came from the porter's office with its large open fire where the students were allowed to heat up their meat pies. Down the passage, past the looming Laocoon and Hercules, there was a kind of den opening to the right where they could boil a kettle for cocoa. Further warmth came from the pipes below the iron floor gratings, through which pencils and brushes dropped. The Back Schools were for private work and kept open till late in the evening.

The system of Visitors (Academicians or ARAs who instructed for a month at a time) had its critics, but at least it gave the students variety. 'Some of this teaching was good and some quite the reverse,' as Kipper mildly put it. Visitors' signatures on his class work include Marcus Stone, George Clausen, Solomon J. Solomon, Seymour Lucas, Luke Fildes and John Sargent. Sargent, of course, dazzled Kipper as he

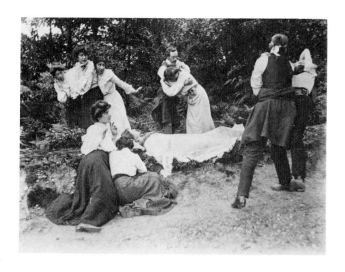

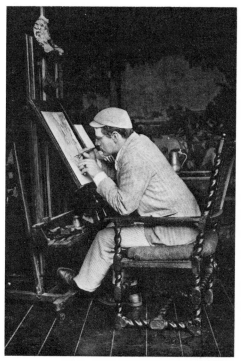

Art students' drama group. Shepard adopted his father's love
of the theatre; he often inspired impromptu productions.

(*Right*) Ned Abbey, the American artist, at work in his studio at
Fairford, Glos.; another great influence on Shepard.

(*Below*) Studio of Frank Dicksee, R A, great friend of the Shepard family.

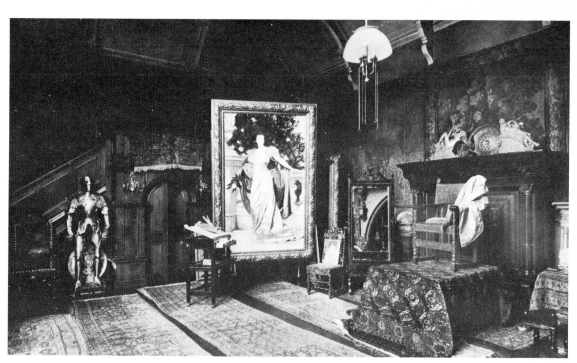

dazzled them all, but the solid reassurance came from Frank Dicksee and Edwin Abbey.

Frank Dicksee was the family friend who had sponsored Kipper's entry into the Schools and supplied an easel for his first studio. A superb Victorian all-rounder, Dicksee could turn his hand to anything – cartoons for stained glass, murals, historical set-pieces, portraits – although he warned his pupils against exhibiting these too often. But he was never set in his ways; on the contrary, he belonged to the ginger group who had voted for reform in the Academy Schools after the death of Millais. Having studied under Millais, he regretted that he had never been taught by Watts, and dreamed of cloudy allegories, which he painted sometimes. These, however, never had the appeal of his low-toned but richly-coloured quiet domestic scenes. *Memories,* exhibited in 1886, commemorates, only four years before her early death, the charm and dignity of Kipper's mother. Dicksee, who never married, but lived quietly in Fitzroy Square with his sisters, concentrated the whole meaning of his picture into the figure of Jessie Shepard, who appears in the final version as a woman in black, gently lit from behind through an open window.

As a teacher, Dicksee was known for his impartiality. It was said that he only gave extra attention to the crippled or the unfortunate. But he made an exception for Jessie Shepard's younger son.

Although Dicksee was kindness itself, he gave his friendship cautiously. E.A. Abbey, on the other hand, Ned Abbey, 'a golden nature, warming like sunshine', as Alma Tadema described him, was readily approachable by all. Abbey, arriving here from Philadelphia, was a visiting American such as England, even in Edwardian days, could rarely hope for. Even before he came he was generously in love with the English weather, with Dickensian heroines and period costume down to the last ribbon and shoebuckle, even with cricket. In 1891 he built himself an English country house, Morgan Hall, near Fairford, with a sixty-foot studio where he encouraged the day's work with music. If a man told you he didn't like Schumann, Abbey said, it was best to look at him again, very closely; there'd be something wrong with him. But both here and at the Dicksees' evening parties Kipper, as a natural music-lover, passed the test.

As a visitor, Abbey passed into the folklore of the Academy Schools. This great man, the friend of Sargent and Henry James, made the rounds

Studies of Ethel, Ernest's sister, 'always a willing model'.

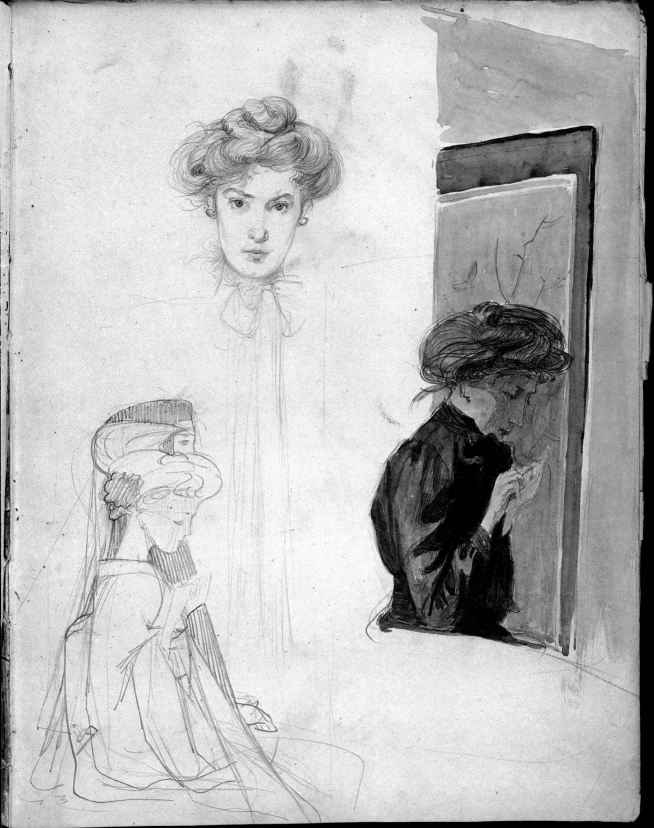

in shirtsleeves and a top-hat which, he said, protected him from drips of
paint. A great believer in the apprentice system, he was always keenly on
the watch for likely students. As his commissions for mural paintings
mounted up he needed many assistants, but Kipper, although he visited
Morgan Hall, was too canny to forfeit his independence. You had to
take the horse-bus from Fairford and tramp across the darkening fields
with luggage and canvasses. 'I have been getting a blowing up from
Abbey for not having done a sketch yet for my wall-painting,' wrote
one of Kipper's friends some what desperately, 'it really is rather rot,
he tells me every few hours that it's the chance of a lifetime'.

What both Abbey and Dicksee impressed above all upon Kipper was
the Victorian value of hard work. And Kipper, though he thoroughly
understood the art of enjoying life on very little money, was an
industrious young man. It is interesting to learn from *Drawn From Life*
that he was allowed a cheap seat at a country circus because the woman
at the door had passed his hands as those of a working man. 'When you
come to the sticking place in your painting,' was Abbey's advice, 'you
must attack it and make it the best part'. This was only possible after
meticulously careful preliminary drawings.

Kipper began to exhibit at the Academy before he finished his formal
training at the Schools. His letters show him anxiously ordering heavy
gold frames, and making expeditions for new brushes to Roberson's, in
Camden Town, where Rossetti and Burne-Jones had been customers
and where Kipper continued to deal until the end of his life. In 1901 he
showed *A Devonshire Valley*, painted at Kingswear, as well as a portrait,
Miss Ethel Shepard (Ethel was always patiently ready to sit, particularly
for the head; she had long thick fair hair which she never cut). In 1903
came *They Toil Not, Neither Do They Spin,* and in 1904 *Followers,* which
was acquired for the Durban Art Gallery – a piece of shameless
favouritism by Dicksee, who had been entrusted with the purchase
money.

The subjects which Kipper chose for himself, however, at this time
show a curiously morbid quality. There are studies for a dead boy,
a child with a bandaged foot lying on a bank of primroses, and a
graveyard 'with fruit-trees in blossom, and a little kiddie burying her
doll'. (March 1903) This may surprise the many people for whom he is
an artist who numbers only sunny hours. The reason was the strain put
upon a penniless young artist much in love, and only able to see his
sweetheart alone, if he was lucky, for one or two hours a week. 'Oh my

From Shepard's
student sketchbook.

girl,' he wrote to her, 'if I could hold your hand I shouldn't be so troubled and worried about money and things, the same old worry you know, that I shan't get rid of till I *do* something'.

Kipper and his fiancée met in the old Lyons teashop opposite the Academy, or, when they could not afford a cup of tea, at the British Museum, to discuss what could in fact be done. The career of a professional painter was much too slow. Kipper advertised for work in the *Studio*, and tried to design picture postcards. Above all, knowing that he was a draughtsman rather than a colourist, he tried to get a footing as an illustrator and black-and-white artist.

Here, too, he could not have had a better adviser than Frank Dicksee, who had been drawing for wood engraving as far back as 1879, producing designs which, as Forrest Reid tells us in *Illustrators of the Sixties,* would have held their own even in that great decade. Dicksee was a master of the balance of black and white within the frame, and one can feel his quiet satisfaction when he solves a problem such as a white moustache in shadow, or a mixture of moonlight and candlelight. Abbey's influence, though considerable, was quite different. Charm, grace, an atmosphere which he himself described as 'quiet and soft and resty', made him instantly popular with a large public. In his element with Goldsmith and Austin Dobson, he set the style for the fluttering ribbons and stagecoaches of the 'illustrated classic'.

Kipper admired other great artists of the Sixties, sometimes un-expectedly. Who, for instance, would have thought that he would have cared for Tenniel, whose hard outline was so very different from his own 'lost and found' line? But Tenniel appealed because of his relentless imagination, which made grotesque fancies as solid as realities. Arthur Hughes Kipper not only admired, but loved, for his lyrical quality. He found it difficult to illustrate *Tom Brown's Schooldays* (in 1904 and in 1959) because he had known the Hughes designs for so long. In 1903 a student friend gave him 'a stunning A.B.Houghton life with lovely drawings', that is, *Arthur Boyd Houghton, with an introductory essay by Laurence Housman,* 1896. Houghton, who worked himself blind and drank himself to death, has always been an artist's artist. Kipper liked his sense of the dramatic and his uncanny insight into the life of children; he also appreciated his use of white. 'It's amazing how much white those old fellows could get away with.' In the years to come, Shepard drawings would blow across the white spaces of a text from one page to the other, but as a beginner he could take no risks. Indeed,

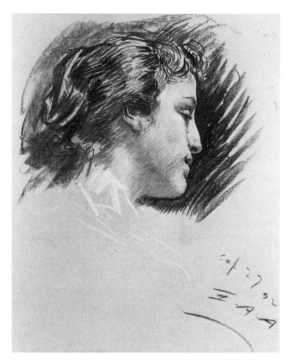

Heads by Edwin Abbey (*above*): Child, Phyllis Parsons (later Mrs
Templer Gosset), 1887, and 'Head of a Woman', 1892; and by
Ernest Shepard: Graham Shepard aged about 2½. 'Head of a Family
Friend'. These are in the immediate pre World War I period.

even as late as 1914 his faithful agent, H.E.Hassall, was writing anxiously to say that the *Premier Magazine* wanted a 'picture of the youthful figure of Napoleon, the Man of Destiny, *vignetted well up to the corners*'.

Finally, there was Charles Keene, whose niece was a family friend, so that the young Shepards knew the comic world of Keene, even without turning to the back numbers of *Punch,* from the collection of his pictures on her walls. It is a world of character in action, magically brought to life with a steel pen and black ink, character shown in every wrinkle in a pair of trousers and action in every waistcoat and street lamp. No part of a Keene drawing is ever 'dead'. On the whole, Kipper considered Keene the greatest of them all.

All these, of course, were influences from the past, while Kipper was a young man hoping to make his career with the new century. He experimented. The cheerful *Impressions of an Art Student's Life* in *The Graphic* (1906) is in the bang-up-to-date style of Dana Gibson, though without a trace of the 'Gibson girl'. In her absence the young painters struggle on with the help of a primitive gas cooker which makes one fear for their health and safety. The cold in their bedroom is suggested in the first picture where their clothes are laid out ready to hand on top of the scanty coverlets. But the public who eagerly read *Trilby,* Kipling's *The Light That Failed* and Henry James' *The Real Thing* were still ready to hear about the life of artists, which seemed in those days so different from anyone else's.

The *Impressions* were Kipper's own, but he accepted, of course, any 'amusing idea' from editors. The *Sketch* asked one week for a drawing of a polar bear sleeping in its white skin and a lady sleeping in her bare white skin. Next week there might be a *Glimpse into History* for the *Illustrated London News.* His ambition, however, was always *Punch.* Abbey, with his usual kindness, had introduced him to *Punch's* senior cartoonist, Lindley Sambourne. 'Here, Sambourne, do you know Shepard? A promising young artist who wants to get into *Punch.*' This was on Varnishing Day at the Academy in the summer of 1904. 'Then he gave me a dig as though to say, "Now get on with it," and left us'.

Sambourne told the young struggler to get hold of some good jokes and 'fire them in'. Kipper went eagerly to work, writing down any he heard on slips of paper. A letter to Florence records his distress, almost despair, when a particularly good one got lost out of the pocket of his

Impressions of student life
drawn by Shepard
for *The Graphic* (1906).

More of Shepard's 'Student Days'.

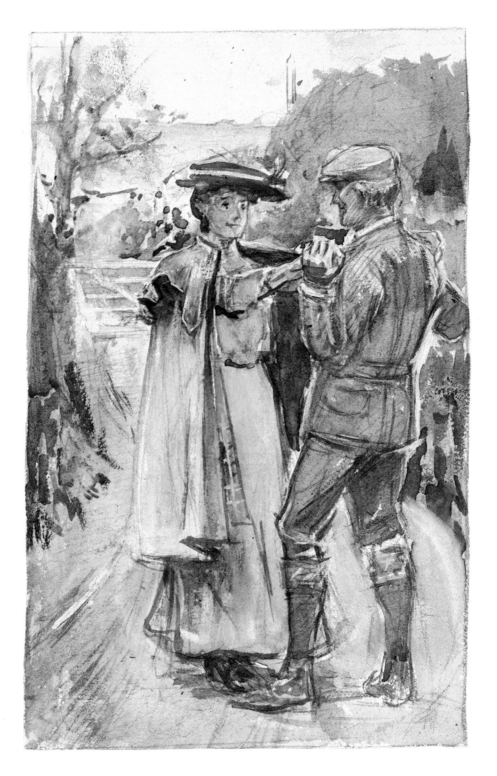

An early example of a rough for a Shepard book illustration.

Norfolk jacket. None was accepted. Meanwhile, his most encouraging commissions were for book illustrations, and the first publisher to give him steady work was Thomas Nelson.

The usual arrangement was for a colour jacket, colour frontispiece, and three or five black-and-white illustrations. For Kipper this meant weeks of drawing from the life before the first roughs were sent in. The conviction, common to all commissioned artists, that the work could never possibly be finished in time, often made him feel 'queerish' and 'knocked up'.

The jacket for *David Copperfield,* a watercolour 10″ × 8″ of Barkis and Peggotty in the van, gave particular trouble. 'No one in the village will sit (or stand)' he wrote in March 1903, from Alford in Surrey, ' *must* get a girl for the figure in the dress'. Then there was no carrier's cart, the nearest one was reported to be at Cranleigh and the young artist bicycled off to find it while Florence was begged to find some red material, faded inside, to give the exact shade for Barkis's trousers. More distracting still, Kipper saw in a teashop a little girl with 'steady eyes' and brown hair and wasted time in thinking how if only Florence and he were married, their daughter might be like that.

The idea of working without models never occurred to him, either then or later. *Tom Brown* was equally exacting. In the nick of time Addie (Florence's sister) discovered that the right kind of little boy was staying with them in their Earl's Court studio flat, and Kipper was able to put in Tom's legs and feet. These anxieties show not only the self-respect of a good artist on the job, but a deep respect for the book itself. Some books, indeed, Kipper believed could never be illustrated at all.

Between 1900 and 1914 he tackled, besides *David Copperfield* and *Tom Brown, Toby* by Grace Allingham, *Aesop's Fables* rhymed by the Reverend G. Henslow, Thackeray's *Henry Esmond, Play the Game!* by Henry Alsop, *Money or Wife* by Effie Adelaide Rowlands and *Smouldering Fires: or the Kinsmen of Kinthorne* by Evelyn Everett-Green. In describing this last as 'very dull', Kipper did it an injustice. There is one gripping scene after another as the island of St. Pierre explodes and the lovers are united in death by the fiery blast. The authoress does not hesitate to make a 'strange visitor' to St. Pierre exclaim 'The girl is mine! You shall not rob me of her!' and even 'I will never darken your doors until Red Thorncourt is avenged'. It is intering, however, to find that Kipper has selected for illustration not these

And there was some money to be earned
in doing dust-covers.

A quietish moment in the drama, 'Smouldering Fires',
now long forgotten.

violent episodes but quiet moments such as 'Dare bared his head with a courtly inclination' (Dare is removing his straw hat) and 'The girl leapt unhurt from the saddle'. The figures are strongly lit from the left by the flames of the volcano and the painful way in which the fallen horse tries to lift its head from the ground is very convincing. Indeed, with the characteristic movement of the design from right to left, which Kipper preferred, the horse has become the focus of interest.

In 1904, on the proceeds of the sale of *Followers* and the payments from Nelson's, Kipper bought a complete Worcester dinner service for £3, a double bed for 10/-, and a brown straw hat for Florence; they rented a cottage at Shamley Green in Surrey, and were married. Graham was born in 1907, and Mary on the Christmas Day of 1909, and Kipper's sketchbooks over the next years are full of delicately-realised studies of the two children.

The young Shepards scarcely noticed the disadvantages of Arden Cottage. 'I went into the larder and a lot of the side of each shelf has a strange green colour you do think it's alright don't you?' Florence wrote cheerfully to Kipper, who was touring the countryside looking for backgrounds. Here, and later at Red Cottage, where the studio still survives, the two of them worked, drew, painted and brought up the children together. There were outings (the children were left with Aunt Fanny) to the Kinerama and the Russian Ballet, where Kipper, in common with so many artists, was given a totally new idea of what movement could be. Meanwhile Hassall still found buyers for both oils and watercolours, which had to be packed and sent off from the crowded cottage. It was only gradually that Kipper came to concentrate almost entirely on black-and-white.

In 1907, after who knows how many attempts – he had been sending in several ideas a week, but always in vain – he succeeded in placing two drawings in *Punch*. The jokes are so bad that we are glad to be spared those that were rejected or lost on bicycle trips.

The Complaint of Philomel might be taken for the work of J.A.Shepherd, a creator of delightfully humanised animals and birds whom Kipper much admired. Mary Ann's face, however, is rendered with the recognisably E.H.Shepard economy of line. The expression of wistful exhaustion, which, by the way, rather weakens the heartless 'joke', is indicated by a few lines and three dots. Although he continued to contribute to the *Sketch* and the *Graphic,* Kipper could consider

Shepard's first portrait in oils of his son Graham,
then about three years old.

Shepard's young children soon become his models
in the pre-war years.

(*Opposite*) The first two of Shepard's illustrations
accepted for *Punch*, February 13 and June 12, 1907.

INSTEAD OF GOING TO THE EXPENSE OF INSURING YOUR DOMESTIC, WHY NOT ADOPT THE ABOVE PRECAUTIONS DURING THE ASCENT OF MARY ANN WITH THE COALS?

"THE COMPLAINT OF PHILOMEL."

THE COMPLAINT WHICH IS JUST NOW DECIMATING OUR YOUNG NIGHTINGALES IS KNOWN AS GALLOPING CATARRH. IT HAS BEEN CAUSED BY THE RECENT SEVERITY OF OUR SUMMER. SUCH A CONDITION OF THINGS WAS OF COURSE NEVER CONTEMPLATED BY KEATS WHEN HE ASSERTED, IN HIS "ODE TO A NIGHTINGALE":

"THOU WAST NOT BORN FOR DEATH, IMMORTAL BIRD!"

GRAVE AND LEARNED.

UNCIVIL BAWLINGS.

AN INSULT TO THE PROFESSION.

Shocked Juvenile. "OH, MOTHER! FAIRIES WOULD NEVER DO A THING LIKE THAT, WOULD THEY?"

From *Punch*, 1913.
A shop with a mountainside of embryo Winnie-the-Poohs.

(*Opposite*) From the *Strand Magazine*,
examples of the work of J. A. Shepherd,
whom Shepard much admired.

himself, by the outbreak of the first world war, as an established *Punch* artist. *An Insult to the Profession* (November 1913) recalls the Christmas shopping of a vanished world.

The figure drawing here is unexpectedly weak, but the whole design is alive. The mother's hat and the father's umbrella both lean backwards in alarm from the ambiguous grotto, while the little girl's bonnet moves trustingly forward. Above all, there are the expressions of the toys. The dolls look anxious or stupidly complacent, the teddy bears are wise. The life of toys is given to them by the imagination of children, and however old and battered they may appear, they preserve that imagination and that childhood still. Kipper had always understood this, ever since he had been parted, at the age of ten, from his beloved tricycle-horse.

The bears, it may be noted, are studies from Graham's Growler, who disintegrated only in the second world war. We can see Growler here in his first youth, with less character, but more fur and plush about him than he was to show thirteen years later in his appearance as Winnie-the-Pooh.

In 1908 one of Kipper's friends from the Academy days had written to beg him not to give up painting. 'There are lots of clever black-and-white men, but there are very few artists who have the charm about their work that makes your pictures so poetical.' This friend did not recognise, perhaps, that Kipper might be able to combine the two.

Idyll at Red Cottage:
Ernest and Florence.

Their daughter
Mary (a rough sketch).

Characters in the Shepards' home village, Shamley Green, Surrey.

1914-1920

Guns, mud and separation

The two great wars that thundered into our world during the first half of this century were, for the very great majority of those who fought in them and survived, periods of awful limbo, time harshly sliced from a lifespan already seen to be too short. There were professional soldiers, of course, who advanced their careers, and deservedly so when they were ones who did well in their chosen calling. There were others who were either propelled, or manoeuvred themselves into wartime positions, not often very near the front line, that did their later careers no harm. Kipper was different. For him 'The Great War' was a natural extension of his life; practically all activity interested him, and this was more exciting than most. He had never made any secret of his admiration for soldiering, and this time there was no uncertainty about the cause. Like almost everyone in Britain (and in Germany too) he believed that God was on his side.

As a married man with children, he was not in the first wave of recruits to be called up, but he and his friend Bruce Ingram, then editor of the *Illustrated London News* (for which Kipper had done some picture work) both applied for commissions in the Royal Artillery. By the second half of 1915 they were doing officer training at Weymouth and Lydd. In later years Kipper explained his choice by saying he had always been fascinated with guns. That was true enough, but he must also have been influenced by his hero-worship of Everard Calthrop, and the knowledge that the artillery valued good draughtsmanship. He was commissioned on December 14, 1915, and joined 105 Siege Battery when it was formed at Dover a month later.

What Florence thought about it all, we don't know; but from her letters it appears that she, like so many wives in England accepted the inevitable with a patience that balanced agonisedly on the scales of hope and fear. They had been so happy. The children had naturally brought a new dimension into the marriage, and Kipper quickly entered into their exploring make-believe. In the lower shelves of an upstairs cupboard he created a grotto, which had imaginary real water and an imaginary real mermaid – his daughter Mary still remembers it. Even when she and Graham were very, very young, there were always plays and charades being organised. The 'acting box', containing all the costumes and the making of costumes was one of the most important features of the house for them. The toys also had characters of their own. In February, 1915, when Kipper happened to be at home, but the rest of the family away in Sussex, he wrote to Graham (aged seven): 'Growler* and Puck** have been an awful nuisance, they talk and jabber all night, and

*Graham's teddy bear, later to be the model for Winnie-the-Pooh.
**A 'cork-filled gnome' belonging to Mary. Louie has passed beyond memory.

THE END OF PEACE
Characters in a world soon to be lost.

I met Louie on the stairs yesterday singing at the top of her voice "Hullo, hullo, etc.".'

Both of them loved their home at Red Cottage; yet both of them still moved around like crickets, Kipper usually on business, Florence and the children visiting friends and relations. Early in 1914 Kipper had bought a motor-bicycle off Jeffrey's of Guildford ('Gunmakers, Motor and Cycle Agents, Sports Depot') and had written to Florence (who was away again) that it was 'all complete except the storm apron and one or two spare plugs and valves . . . my word it *does* look nice, and a ripping little comfy side-car, like an armchair.' He was getting more regular work for *Punch*, but they were only paying three guineas for half a page, and he would go chasing any commission for almost any of the myriad illustrated magazines that then proliferated in Britain. Owen Seaman, then editor of *Punch,* asked him to try and do some jokes outside the scene of war, and Kipper complains that it is impossible to think of anything else. By the time he was called up, the motor bike had suffered some very hard riding. In January, 1916, just after Kipper had gone to Dover, Messrs Jeffrey's wrote: 'We regret to report that the engine needs overhauling, either the big end or crank pin having gone.' Cyril was in khaki too, doing officer training in Surrey. When he first joined up he was staying with Florence's mother who had another daughter, Alys, with her. But now Cyril was ordered into army billets not far away, and Alys, who had a family reputation for minding everyone else's business, didn't see why he should move. Cyril and Kipper fresh in the terrorising grip of uniform, explained to her exactly why. Alys eventually agreed that Cyril was 'probably right about being billeted where he was told,' (wrote Kipper to Florence), 'but that *she would see the sergeant about it*. This has finished Cyril – fancy her poking round the headquarters of the OTC.' War still had its amusing side while they remained in England, but this was not one of the jokes Kipper sent to *Punch*.

105 Siege had been established as a 12 in. howitzer battery, but in the early war unpreparedness it had to do with what guns it could get. In May it left its 12 inch howitzers in Dover, went across to France, and at Tincques took over some 120 mm French long guns. They went into action for the first time on June 10th in front of Mont St Eloi. Of course Florence didn't know where they were, and she kept her letters admirably offhand, but she couldn't always prevent the nervousness breaking through. 'Addie' (sister) 'sent me a wire in the morning to ask if she could come,' she wrote on June 17. 'I wish people wouldn't. You

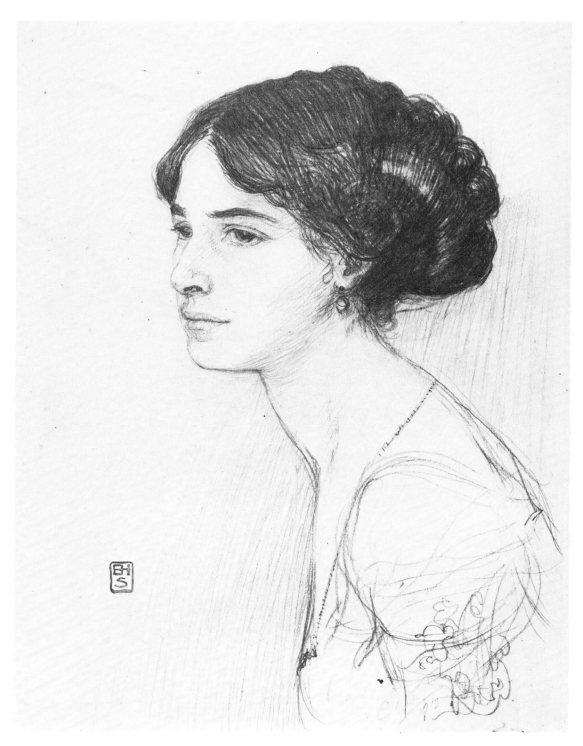

Shepard never tired of drawing his wife.

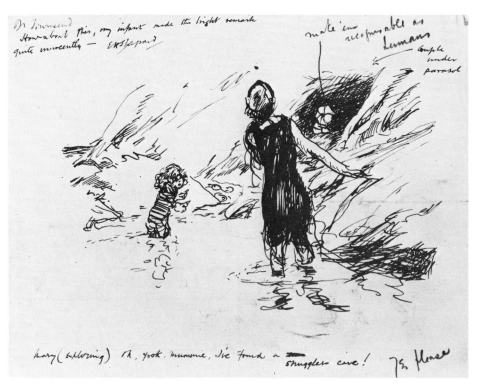

A Shepard idea is accepted for *Punch*, with a forthright suggestion
('Make 'em recognizable as humans') from the art editor. Daughter
Mary is the principal character involved. But Shepard did have
trouble finding jokes.

Observation post view at Mt Eloi, where Kipper and 105 Siege Battery
went into action in France for the first time.

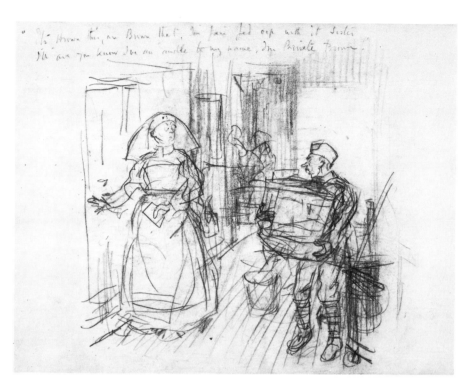

SOME OF SUSIE'S SISTERS SEWING SAND-BAGS.

Hospitals and all war-work provided routine jokes.
Shepard went to France in 1916.

can't think how rotten it makes you feel to get one now.' The battery moved again when Douglas Haig's Somme offensive began on July 1st, and Kipper began to fight through the bloodiest battle of them all. Early on, during a brief spell off duty, he was able to go and find his brother's grave at Mansell Copse, near Fricourt. Cyril had married a Devonshire girl a month before he embarked for France, where he arrived not long before Kipper. Cyril was with the reserves of the 9th Devons, and found himself pushed into the battalion as an acting 2nd lieutenant just before it became part of the first wave of the Somme attack. He was killed almost immediately on that opening day.

There was nothing amusing about the Somme, but Kipper's letters sustained their usual equable humour. Again he seems to have been writing almost every day, as was Florence, and he gave no inkling that he was grinding through that heartbreaking wartime chore of putting down nothing that would say anything significant about himself and yet nothing to convey a whit of anxiety at the other end. He wrote of mud and weariness and vermin as though they were his worst enemies, and those all subdued beneath cheeriness and love. So that, a fortnight after the struggle on the Somme had begun, Gray was able to write to him, solemnly: 'I hope you are quite well and am so glad you have defeatid the flees.'

In September they returned their 120 mm to the French, and were issued with 6 in howitzers. Kipper was intrigued by all armaments, and his gun drill books are heavily underlined and annotated. 105 Siege Battery was in almost continuous action, supporting XIII and then XIV Corps until the Somme battle savaged on to an exhausted end in November, with its 614,105 British dead. The battery had been comparatively lucky in its casualty rate, and as he was still only a second lieutenant, Kipper had to wait until early in 1917 before he could get home leave. His friend Bruce Ingram left the battery to join the staff. Kipper took back to England with him some of the pictures he had done in France. And this was another aspect of his special war. Though he had become thoroughly and enthusiastically a soldier, he never forgot (never could have forgotten, he might have said) that he was an artist, that it was in drawing and painting that his future lay. He used to say afterwards that he got no work done in the war years, but for an active soldier – who certainly didn't neglect his duties – his output was surprising. Incidentally his agent, H.E.Hassall, apparently refused to recognise that a world war might interfere with his client's labours. On July 15, 1916, over two weeks after the start of the Somme attack,

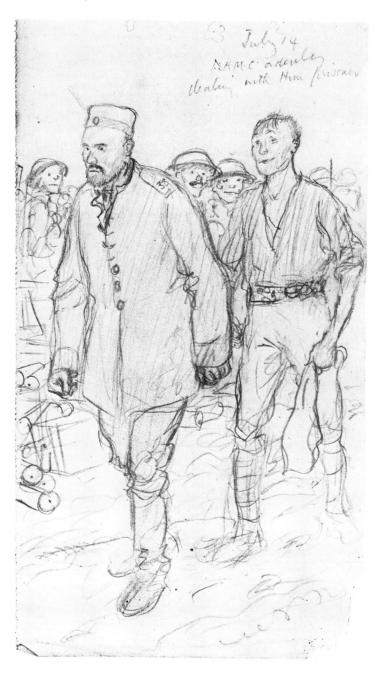

Shepard had written in pencil on the back of this sketch: 'one of
our fellows, the morning after an attack, went to wash and came upon
a huge Bosch (*sic*) lurking in a dug out – the Bosch surrendered
promptly and Tommy insisted on marching off his prisoner himself –
it was the most delightful sight to see them going down the road,
Tommy in his shirt sleeves and armed with a towel, stalking
proudly behind his gigantic capture.'

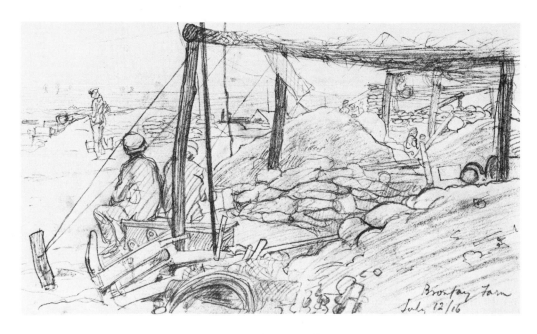

A lull in the gun position.

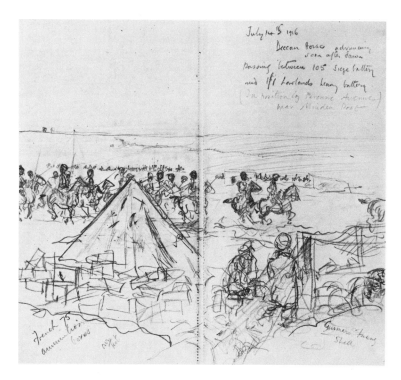

1916. The Indian infantry had all been moved from France
and most of the cavalry was unhorsed and in trenches.
Shepard captured a rare glimpse.

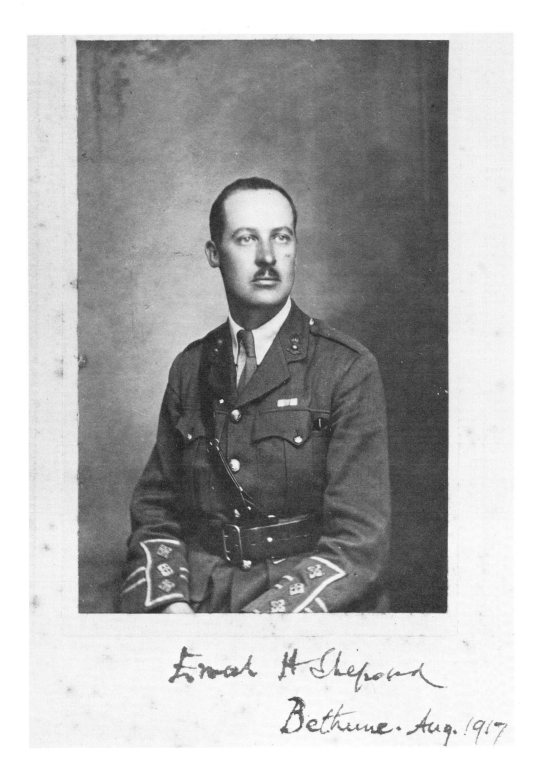

Ernest H Shepard

Bethune. Aug. 1917

Captain E. H. Shepard, R A.

he wrote to Kipper to say that the editor of *Premier* magazine was anxiously awaiting the third illustration for the story '*The Scarlet Mark*' – and he also wanted very much to know where the manuscript of the story had got to. Hassall added the bad news that the cheque paid for a drawing in *Woman's Realm* had bounced, and the journal had ceased publication. I find no evidence that Kipper answered that letter, though it wouldn't surprise me to learn that he did so. He was sending off contributions whither and when he could, for Florence, as her letters show, seldom had any money to spare, though she was far from extravagant – and she didn't complain. When he was at home at the beginning of 1917 he did a few sketches for *Punch*.

He was back in France by the end of March for the battle of Arras (April 9 – May 15.) In a letter of April 17 to Florence he describes going up to the observation post in the front line trenches, explaining that the infantry right up front don't always welcome gunners, but that he had some whisky with him ('don't tell Aunt Ellen'), and he handed it round, and he seemed to get on all right. He was excited about his job in the observation post, and quite delighted when a visiting general congratulated them on all they had done. When he went back to the battery after that day's work (his guns were a good five miles behind the lines, which is why the PBI don't always like gunners), he found that the mess officer had been back in town shopping, and had collected 'whisky, squareface, salmon, lobster and biscuits'. You can almost hear him thinking: don't tell the infantry. It was a good mess, and it must have contained some first class officers, for at least half a dozen of them won military crosses, not easy distinctions for 'long distance' gunners. A siege battery was a congenial unit to belong to; there were some six officers and 155 men to work the four guns, or proportionately more to a six-gun battery. The battery, though often regimented with others, was its own self-contained entity, small enough for all to get to know each other, and to provide no room for anyone to stand on his dignity. It admirably suited Kipper's infectious friendliness. But though 105 Siege Battery had been lucky – comparatively, I repeat – through the long months of the Somme, it suffered sharply in the five weeks of Arras.

The enemy ranged in on their guns, and they began to take casualties early on in the battle. It was certainly no better in the infantry trenches, where Kipper spent much of his time as OP officer. His two signallers, Taylor and Clarke, would keep as close as possible to him wherever he went, though he pointed out to them that if they continued like that a

Florence and Graham, a sketch done while Shepard
was on leave at Shamley Green.

The New-comer. "My village, I think?"
The One in Possession. "Sorry, old thing; I took it half-an-hour ago."

single shell might knock them all out. The signallers were obstinate; 'they said they felt safer when they were near me'. Kipper was tagged as a good luck charm. On April 23, in an early morning attack, 105's gun position was again heavily shelled, and there were a lot of casualties. The CO, Major d'A.J.Richards, was seriously wounded, and 2 Lt. E.H.Shepard found himself in temporary command of the battery. Nevertheless he was again up at the OP that evening, and for the 'cool and courageous' work he put in during the night April 23-24 he was in May awarded the MC, and also promoted to captain.

After Arras, it was the Third Battle of Ypres (July 31 – November 20), still under Haig's direction. If not quite as bloody as the Somme it was equally beastly, fought over reclaimed marshland that 105's guns (helped by over 2,000 others on the British side alone) turned into a melting bog. 'To persist after the close of August in this tactically impossible battle,' writes General Fuller in *Decisive Battles of the Western World*, 'was an inexcusable piece of pigheadedness on the part of Haig . . .' The soldiery, cursing and floundering on, found it no more nor less tactically impossible than any of the other frightening messes they had been flung into. The nights up in the OP must have been almost unbearably long, even in the summer. Men who could achieve sleep had nightmares; those who could not saw visions. Kipper, trudging up to the OP one evening, was surprised to pass a bob-tailed sheep-dog lying, apparently dead, by a shell-hole. When he reached the front trenches he asked several people whether they had seen the dog. Nobody had; one or two gave Kipper a queerish look. In the dark hours of early morning he was alone, looking out from the fire-step, his signallers asleep, when he felt someone at his elbow. He looked round to see a Belgian farmer in peasant smock, who began to call for his dog, Flaton. He turned and asked Kipper if he had seen the animal, but, without waiting for an answer, moved away round a corner of the trench. Kipper asked around, of course, but no one else had seen the farmer. It was typical of Kipper's obstinacy in proving things to himself that he even bothered to ask. And in the daylight, when he started his walk back to the guns, he passed the same shell-hole and there was no sign of the dog. Many men saw strange things after days of battle in Flanders, and were amazed. Kipper often wondered interestedly about what he had seen but never sounded over surprised. He always said he had 'second sight', and there must have been plenty of good pasture out there in no man's land, before the gunners started shelling it to pulp.

Civilians observed while Shepard was on leave.

Mary and Graham,
the models on which Shepard
based so many drawings of children.

105 Siege Battery was pulled out of 'Third Ypres' a little before the end of the battle, and everyone started reckoning his priority for home leave. Kipper did some more chalk drawings, and sketches, and collected some souvenirs to take back for the children. He was dying to get back to the family, especially to Florence, who was finding it harder to keep from her letters the misery of separation. She had taken Gray and Mary on a holiday in Devon, and Kipper tried to comfort her: it was 'so good to hear all about the hills and the sea and the loneliness of it all. I can just imagine my girl enjoying it all to the full. I simply *absorb* it all, and almost feel as if I were there when I read your letters. As a matter of fact I often am, just jogging along beside you or sitting close to you . . .' On October 24, a week after Kipper had written that letter, the Austrian army, supported by seven German divisions, smashed through the Italian position on the Isonzo river and only halted their advance when they were within 20 miles of Venice. At Caporetto the Italians lost over a quarter of a million prisoners and 3,000 guns, and a mass of other arms and equipment; worse, the murderous but seemingly endless deadlock on the southern front had been broken with a vengeance. After the first panic, the British looked to see what reinforcements they could send to Italy. 'Once,' wrote Mary much later, 'for nearly a month we had no news at home, and tried to comfort our mother. Graham very wisely suggested that Daddy was being moved. He was right.' He was indeed. In France, with a week of November gone, Kipper worked out that his home leave was almost due. On the 12th all leave was stopped, and two days later 105 Battery received orders to move, with guns, to Italy. ('For some time,' Mary added, referring to this transfer of Kipper's, ' "being moved" for Gray and me connected with the war, and the Zeppelin. That was when the Zeppelin trundled past Shamley Green on its way to the target, the Guildford to Kent railway, which carried munitions. My mother woke us up and we saw the Zeppelin quite clearly. A near miss was scored with a tiny bomb on Shalford Meadows, killing a sheep'). Kipper was in a very different war, a long way from home. The battery had taken five days to move down through France to Isola-Della-Scala, and Kipper was making his first acquaintance with Italian artillerymen: 'I found the Italians, who had the reputation of being the finest heavy gunners of all, knew nothing about ranging with aeroplanes. I had to teach them from the beginning.' He was amazed, but not altogether displeased.

On December 6 the battery moved into position on the Montello, behind the Piave river, and was in action almost continually, with the Italians, until March, when it was moved to the Asiago plateau. It was

Sketch for *Punch* drawing: 'The Scroungers,' Nov. 1918. The caption was: 'Wot about it, Bill? Shall we be pushin' on or shall we wait till the trains get runnin'?' Shepard was still rather painfully making efforts to draw funny faces.

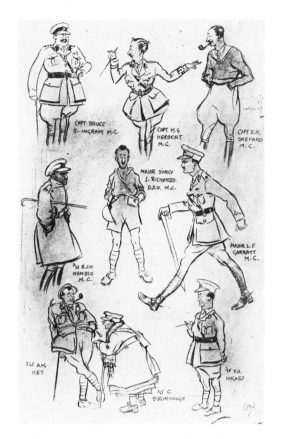

The inevitable caricatures of the Officers Mess.
They had it printed as a postcard.

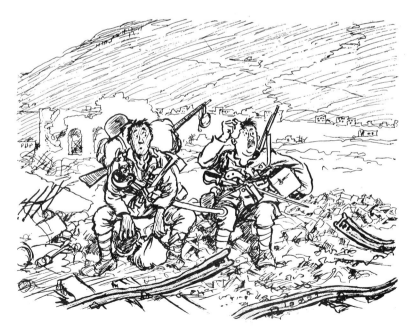

on Monte Torle when on June 15 the Italians, early in the morning, put in a strong attack with gas, and the two sides began to slog it out in heavy rain. That was the start of the battle of the Piave, which ended three weeks later in complete victory for the Italians, with all the enemy pushed back across the Piave. Then there was quiet until October 23, when 105 Battery joined the mighty barrage that opened the ten-day battle of Vittorio Veneto and the total defeat of an Austrian army which by then would have been glad to accept defeat without any fighting at all. It was the end of Kipper's war, and on November 7, only four days after the Austrians had accepted imposed armistice terms, he was writing to Florence about his gratuity: '310 days' pay (about £177). Pretty good, isn't it? Enough to buy a new suit for Kits, a complete outfit for Mont (including some honeymoon undies), and 12,000,000 nosebags, and still have enough left over for Frog's school.'

It was the end of Kipper's war, but there was still much waiting to be endured. At first, it was arranging for all the prisoners and guns they had captured. Kipper sent Florence pictures of some of the prisoners arriving ('keep the coloured ones'), and as for the guns, headquarters were asking if anyone would like to take a few 'for regimental depots, territorial towns, etc.' 'It would,' wrote Kipper, 'be rather fun to present a captured gun to Aunt Ellen . . . there's a cheap line in 10 cm. howitzers.' And of course, like so many others, he was having anti-tank shells mounted and polished up for him – 'little beauties for our mantelpiece.' He enjoyed Italy and the Italians, as he always enjoyed being abroad, but by January 1919, with still no sign of demobilisation, he was becoming restive. He complained – and he so very rarely groused – that later arrivals than he to the battery had discovered that if they could wangle themselves into a hospital on some pretext, they could then get their release date advanced. Owen Seaman had promised to write to the War Office, demanding a quick return of his artist's services, but that didn't appear to have made any difference. On January 11 he was promoted acting Major, a distinction he would have received gladly before, but now it meant staying on to supervise the problems of a disintegrating unit. In the intervals of this irritating work, he went on drawing. 'I've sent my Puncher off,' he told Florence that same month, 'so if they take it that'll be another eight guineas for the funds'. *Punch* had advanced its rates, but they still weren't princely, and Kipper was not yet so firmly established as to be able to ignore the fear of rejection.

Through the introduction of a common friend he went to see Ernest Hemingway in hospital in Milan, and was not very impressed at this

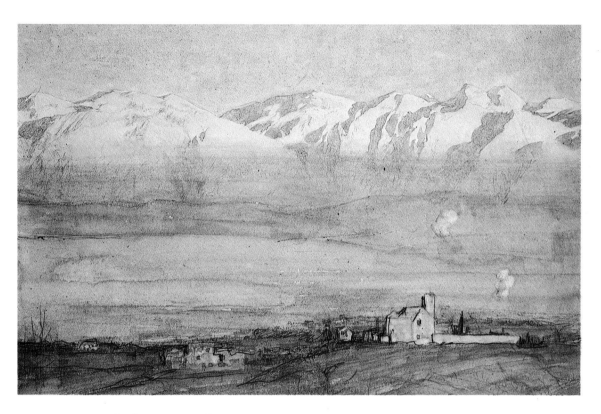

On the River Piave, Shepard's view from an observation post on the Italian front.

particular preview of *A Farewell To Arms*. Kipper's main preoccupation
seems to have lain in avoiding a date with one of Hemingway's girl
friends, generously offered by the ailing author. Kipper thought – and
in a matter of this kind he is unlikely to have been wrong – that she had
her eye on him. And then, in March, the battery received its movement
orders. Once again they loaded their guns on to railway flats and took
the long train journey, winding up through France to Calais. There the
battery ceased to exist, officers and men were shipped home as individ-
uals, and Major Shepard had presided over the disbandment of a unit
which he had joined on its formation, little over three years earlier, as its
most junior officer. It was a rounded performance, unusual in war.
Afterwards, Kipper always thought of himself as a gunner, but especially
as a gunner of 105 Siege Battery. So he went back to Shamley Green in
the spring, when the splendid woods of oak and birch and rowan were
beginning their year again, and the bluebells, to quote his daughter
Mary, 'grew so thickly that there was nowhere to sit down for a picnic'.
He had his gratuity and his sound connection with *Punch* and nothing
much else but his tested skill as a draughtsman and an indomitable
optimism. They were to prove admirable assets.

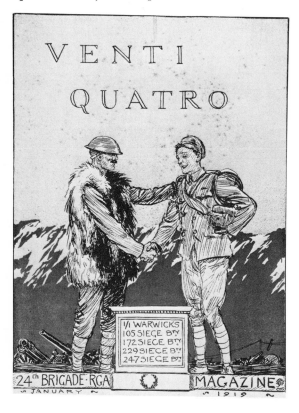

Original for cover of Corps magazine.

1920-1940

Success, tragedy and professionalism

Back from the war, Kipper would quite surely have started work again as soon as he reached his studio at Red Cottage, but it happened that he arrived to find work waiting for him. He had *Punch* to supply of course, but also his agent, H.E.Hassall, had been in touch with Hugh Walpole about illustrations for a book that was a new departure for that wide-ranging author, a semi-autobiographical novel of a small boy. *Jeremy* was published before the end of 1919, so Kipper must have been hard at it very soon. Copies of this book are rare now, and there is no record of it having been outstandingly successful. Kipper, who had illustrated an edition of *Tom Brown's Schooldays* in 1904 or '05, had established his position as a portrayer of youthful figures. In his sketch of Graham, probably done on war leave (page 93) he had given himself an archetypal schoolboy; but he probably got this job in the flood of goodwill towards returned soldiers. He and Hugh Walpole were far from a temperamental match, and one can only say that Kipper did not illustrate the author's further two books on Jeremy. For Kipper, a failure in collaboration was very rare.

In June 1921 Sir Owen Seaman invited Kipper to join the *Punch* table, which in fact meant an appointment to the regular staff. *Punch* relied much on outside contributors, but the basis of the paper was laid every week by a dozen to fifteen staffers who met every week at dinner with the managing director (though the editor presided), to decide the two political cartoons for the coming issue. (Later the meeting was held over lunch. Too often, after the dinner, editor, cartoonists and the rest of the staff seemed to have differing recollections of what they had decided). Kipper naturally accepted, and suggested, since he had been asked to, a regular fee – of eighteen guineas for a half page and twenty-five guineas for the whole. Since he was far more likely to be asked for half-pages, his generous concession for the large size was shrewd enough. Philip Agnew, then managing director, formally invited him to his first dinner on June 15. Kipper, in replying, noted that one of his wife's grandfathers was a founder of *Punch*, Ebenezer Landells, who 'was, I believe, a somewhat cantankerous old body'; and he said he 'regarded it as a high honour to be admitted to the brotherhood'. That was no mere courtesy. For black-and-white artists *Punch* was still re-garded as the best possible exhibition gallery, as Kipper's mentors had impressed on him from art school onwards. The appointment, though it carried with it an obligation to send in, regularly, at least one drawing a week – not a chore that would bother Kipper much – meant a virtual certainty of acceptance, and a regular income, something Kipper had been searching for ever since his marriage. Kipper was honoured too,

Shepard's first book illustration after World War I
was for Hugh Walpole's *Jeremy*. Sketches for Jeremy's dog.

Notebook sketches, perhaps for *Jeremy*.

PEACE BREAKS OUT AGAIN
When you could draw something
other than war.

because he had not yet produced a truly settled style. He was not satisfied himself; you can tell from the way he drew, redrew, and re-redrew his sketches – that is what made him so good. There was still too much fussy hatch-work, and a non-regular reader of *Punch*, or one artistically unobservant, could still mistake a Shepperson (the drawing as well as the signature) for a Shepard. He did not want to be typed of course, but he did want to be instantly recognised, and in a magazine like *Punch* it was difficult to achieve both. Nor did he find it any easier than before to make his own jokes, and he was often calling on the office to produce them for him (in this he was by no means alone among the regular artists). But in the office at 10 Bouverie Street, they had recognised his potential. Townsend, the art editor who had so encouraged him, died shortly before Kipper's appointment to the table, but Frank Reynolds, succeeding to the post, was another good friend who appreciated the new staffer's value. 'With Shepard,' wrote R.G.G.Price in *A History of Punch*, 'the rest of *Punch* began to look static. How heavily other men's dowagers sat on their chairs, their horsewomen on horses, or their judges on benches. Even when the scene in Shepard was a conversation one feels that there was a wind in the room and that someone had just moved and that someone else was about to move.'

Kipper settled in well at the table, most of whose members he knew casually already. Once again his boundless interests helped the process. Many were daunted by Sir Bernard Partridge, senior political cartoonist, but Kipper learned that he had been an actor (had indeed played Laertes to Forbes Robertson's Hamlet), and had appeared with Ellen Terry and Henry Irving, both of whom had been friends of one side of Kipper's family or the other. Any ice was soon broken. E.V.Lucas was there, very much the grand man of letters, but soon responding to Kipper's natural friendliness. Lucas was also a director of Methuen, the publishers, and it was he who first suggested Kipper should illustrate some children's verses A.A.Milne was writing, some of which would be used in *Punch* before appearing in book form. People like Lucas and Milne held a strange position as aristocrats in the world of *belles lettres*. Milne had several plays behind him by 1921, and so trod a broader field, but his fame, like Lucas's, was based on the light essay and light verse. Almost any everyday event, from the vicar's tea party to the dustman's round could, by a felicitous application of words, be translated into a humorous, or semi-serious article, or into amusing rhyme. The inspiration, seasoned by a formidable knowledge of libraries full of authors from the past, was all around them, and seemingly endless. I remember my father (whose own considerable

Sketches and pictures for *Punch,* including one of Nellie
Thumwood (*centre*) who, on answering the Shepard's new telephone
for the first time, put on a clean apron out of respect.

reputation rested on the same kind of output) laughing at Lucas's comment on hearing that a fellow scribe had decided on a long trip abroad: 'What's wrong with him? Written out?' To these men the artist, the picture-maker, was the non-commissioned officer in a parade of talent. Lucas, as a publisher, knew very well the value of the artist to a writer of his genre, but he'd have died rather than admit it. If Kipper noticed these subtleties, he never showed it. He always took each and everyone as he came.

Milne's new verses were *When We Were Very Young*. At first the author was not at all enthusiastic about Kipper; he was probably looking for the owner of a name as well-known as his to be illustrator. But Lucas was influential and persuasive. Kipper did the drawings for the eleven verses that were to appear in *Punch*, and Milne was convinced. For *Punch* they were something quite new, new even as Shepards. They had the immediate charm and fresh precision of so many of his sketches, attributes that sometimes seemed to get lost in the elaboration of the finished work. Kipper was probably lucky in having an art editor to work for as well as the author. Owen Seamen was much disturbed at the idea of having line work darting around in places where there should by rights be solid print, separated by a decent dividing line from the drawing, but Reynolds convinced him, and helped to discipline Kipper's work. The size of the *Punch* page made the illustrations even more effective than they were in the book published later that year (1924), as can be seen here in The King's Breakfast; and even more so in Lines and Squares, for which the book had to omit the bear which has just finished breakfasting on a business man unwary enough to step on a line. E.V.Lucas took good note of the effect of his own advice, and within a year Kipper was illustrating a book of his verses, *Playtime and Company*.

For the rest of the decade, commissions came in thick and fast; between 1925 and '27, especially, Kipper could hardly have had time to stop drawing. In 1926 G.Bell and Sons published *Everybody's Pepys*, an abridged version of the diaries, for which Kipper did no fewer than sixty drawings, all but one of them full page. The planning of this book was like an old artillery reunion, for G.H.Bickers, a director of Bell's, who engaged Kipper, had for a time during the war served with 105 Siege Battery, and the editor, O.F. (later Sir Owen) Morshead, was another siege gunner who had been through similar experiences in the war. The *Pepys* was an instant success, and led Bell's to launch later ventures in the same style; *Everybody's Boswell* (1930) and *Everybody's*

Later to appear in the book
When we were Very Young
1924.

Ernest Shepard and Florence
in post-World War I Venice.

In Normandy – from E. V. Lucas's
Playtime and Company (1925).

(*Here and on following two pages*) *Everybody's Pepys* was the first
of three 'historical' enterprises that Shepard undertook for
G. Bell and Company (the others were *Everybody's Boswell* and
Everybody's Lamb) and was probably his best in this genre. Note
Shepard's attention to detail, both in architecture and costume,
and the care he took over the first sketch for Nell Gwynn (*above*).

Lamb (1933). Both were illustrated by Kipper. In 1926 he was finishing the drawings for a new Christmas edition of Charles Dickens's *The Holly Tree*, and also doing the sketches for Milne's *Winnie-the Pooh*.

Kipper was doing well, and however hard he worked the strain almost never showed in his drawing. After the war he had bought a Triumph motor cycle and sidecar, which he rode to Guildford station to catch the train when he had to deliver his contribution to *Punch*. That changed to a bull-nosed Morris, and later there was an Austin. The family went on joyous summer holidays with the Gossages to Cornwall, the children riding for preference in the Gossages' lorry (because the Gossage Daimler hadn't at first been converted back to petrol from gas, which had fuelled it for war work). By the time the Shepards went over *en famille* to visit the Milne's at Cotchford Farm, the Austin was the transport. After the success of *When We Were Very Young*, Milne had definitely accepted Kipper's work. When he started to plan *Winnie-the-Pooh* he told him that he must draw the pictures for the book. Yet the two men were never close. 'I always had to start again at the beginning with Milne,' said Kipper, 'every time I met him'. Milne's letters were always friendly but nonetheless formal, considering the involvement of the collaboration. Milne's instructions were detailed, far more so than any Kipper had received from other authors. And Kipper went to immense trouble, going down to visit Milne at his Cotchford Farm home, in Hartford, Sussex, and wandering round Ashford Forest, to get the feel of the countryside that Milne hardly ever described in print. He drew sketches and had photographs taken of Christopher Robin and the toys. Later, when publishers' returns had reconfirmed the success of their partnership, Milne was almost honeyed in public. There was the verse:

> *"When I am gone*
> *Let Shepard decorate my tomb*
> *And put (if there is room)*
> *Two pictures on the stone:*
> *Piglet, from page a hundred and eleven*
> *And Pooh and Piglet walking (157) . . .*
> *And Peter, thinking that they are my own*
> *Will welcome me to heaven."*

Those who knew Milne will not miss the sarcasm in the penultimate line. But in fact Shepard *had* appropriated Christopher Robin's companions and made them his own creations, largely because he could see into the mind of a child, any child, better than the father, in

this case, could see into the mind of his own. Christopher Robin was a late and only son (he has, in his autobiography, *The Enchanted Places*, described with amused dignity his unsolicited nursery fame). Milne obviously doted on him, but looked at him and reported on him with that literary mind of his. Kipper understood Christopher Robin's loneliness as Milne did not. When the Shepards went to visit at Cotchford Farm, Mary recalls, Graham, more than ten years C.R.'s senior, went to play with him down by the stream – with an old log floating there that became a battleship, an alligator, anything that might take to the water. C.R. reacted with the delight of one who had never known anyone older than himself actually *playing* games with him. Kipper's mind could always play, but it is hardly surprising he never became intimate with Milne, and indeed Milne may not have wished it. Those literati of the 'twenties could be a strange breed, masters of the prickly hand in the velvet glove. There is that Milne introduction for *Fun and Fantasy*, Shepard's *Punch* collection: '. . . When an author produces a book entirely on his own, no artist is asked to write an Introduction, whereas the book of Shepard cannot make its charming bow to the world unless Milne, or somebody respectable, has agreed to chaperone it. Mr E.H.Shepard, of all people, needs no introduction at my hands. Anybody who has heard of me has certainly heard of Shepard . . .' Again Kipper never worried that this barbed banter might conceal a measure of jealousy.

a sketch made on the spot when I visited it with A. A. Milne

The visual characters that Shepard made of A. A. Milne's inspired
collection of Christopher Robin's friends are universally known,
and any added description would be insult to artist and author
(let alone the reader). In this sketch 'Where it all happened',
drawn in the Ashdown Forest area near Milne's Sussex home, Shepard
set the scene for himself, the background against which he could
draw the animals pursuing their importantly zany courses, thoughtfully
guided by a nicely puzzled Christopher Robin.

Here is Edward Bear, coming downstairs
now, bump, bump, bump, on the back of
his head, behind Christopher Robin.

The bees were still buzzing as
suspiciously as ever.

'Coming to see me have my bath?'

'It all comes,' said Rabbit sternly,
'of eating too much.'

G H Shepard

Chap. II "Trala la-Trala la" (Winnie the Pooh)
p. 21 original background
p. 21.

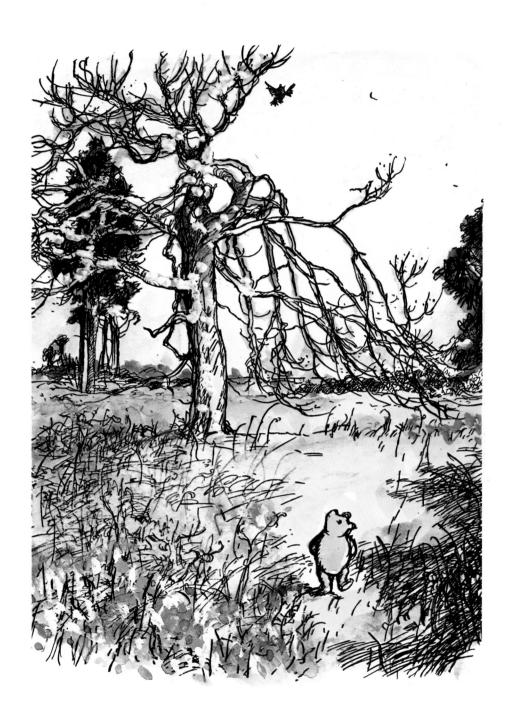

'Just one more jump, Roo, dear, and
then we *really* must be going.'

And in three large jumps she was gone.

She took a large bar of yellow soap
out of the cupboard.

Kanga was scrubbing him firmly with
a large lathery flannel.

Christopher Robin shook his head again.
'Oh, you're not Piglet,' he said.

The Piglet lived in a very grand
house in the middle of a beech-tree.

'Handsome bell-rope, isn't it?'
said Owl.

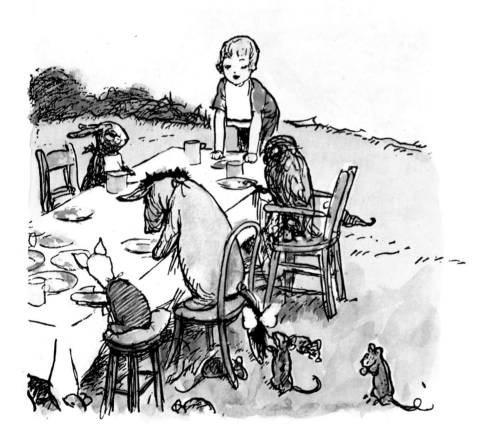

Christopher Robin had made a long table
out of some long pieces of wood, and
they all sat round it.

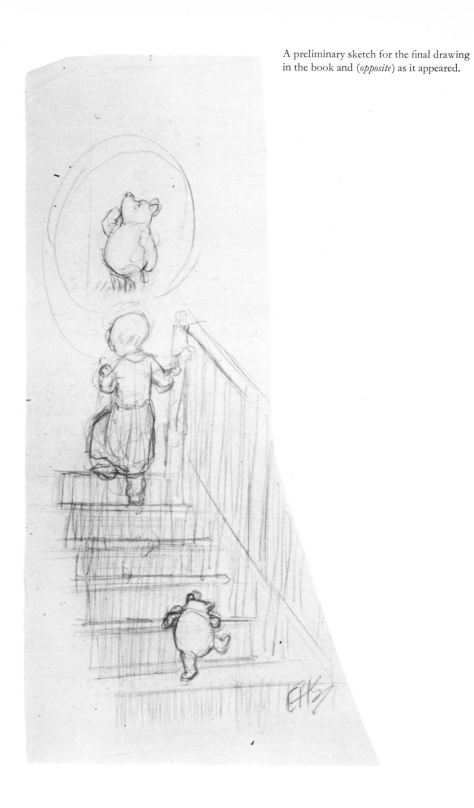

A preliminary sketch for the final drawing
in the book and (*opposite*) as it appeared.

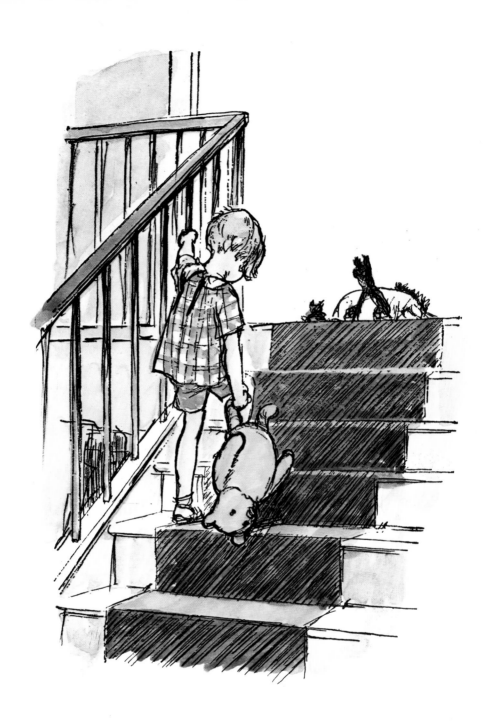

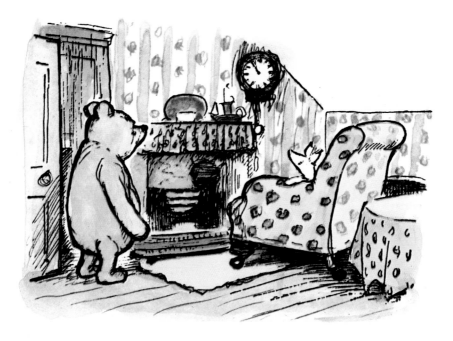

He suddenly saw Piglet sitting
in his best arm-chair.

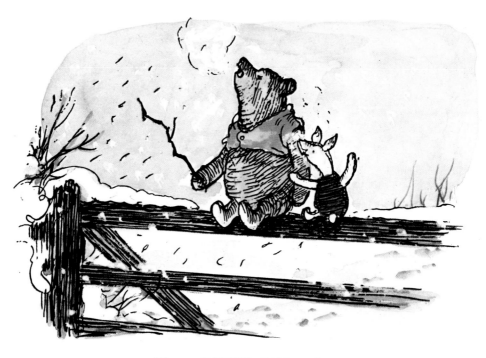

'The more it SNOWS – tiddely-pom'

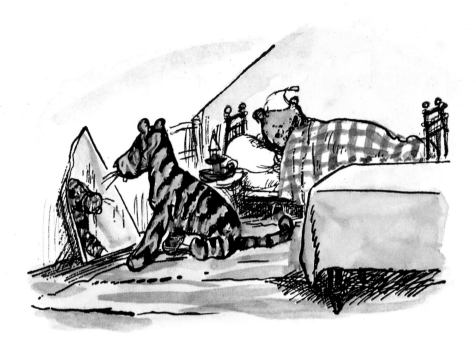

'Hallo!' said Tigger. 'I've found somebody
just like me.'

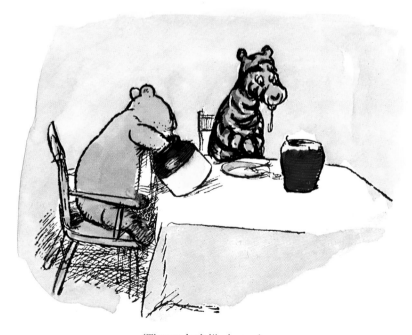

'Tiggers don't like honey.'

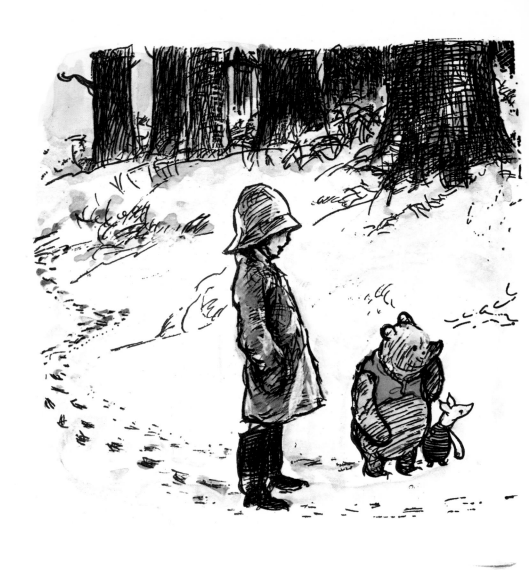

'*That*'s the way to build a house,' said Eeyore proudly.

'Let's go along and see Eeyore,' said Piglet.
So the three of them went.

'Ow!' he shouted as the tree flew past him.

It was going to be one of Rabbit's busy days.

'Ha!' said Rabbit. 'I must tell the others.'
And he hurried off importantly.

'Here it comes! A very – big – grey –
Oh, no, it isn't, it's Eeyore.'

'Oh, Eeyore, you *are* wet!'
said Piglet, feeling him.

Christopher Robin came down from the Forest to
the bridge, feeling all sunny and careless.

'*I* think we all ought to play Poohsticks.'

Poohsticks Bridge and the
men who built it.
The photograph was taken
at the time of its
completion in about 1907.

new
ceiling

Letter box
important

[handwritten manuscript text, largely illegible pencil draft]

To see the Wolery upside down, as it almost was after the storm
that so disrupted Owl's life, Shepard first had to see it the right
way up. So this sketch allowed him to keep track of the gyration
of the Wolery, once the wind began blowing.

138

Chap. IX
P. 153

"Eeyore Finds the Wolery"

They had got a rope and were pulling Owl's
chairs and pictures and things out of his old
house. (With Shepard's original sketch.)

The Shepards had graduated from a motor cycle to an Austin car, but Kipper still wasn't being paid what he was really worth. For his work on *When We Were Very Young* he received only a moderate sum, and no royalties; after which he changed his agent and determined not to allow that mistake again. But he was doing so much, on top of his regular salary from *Punch*, that he was obviously earning the respect of his bank manager, and he set out to build Florence and the family a new home, Long Meadow, on the Pewley Ridge of Longdown near Guildford, in the district that he had enjoyed so much as a boy. It is a lovely position, and the house was of grand design, with a splendid studio. The building went on through 1927, and shortly before it was finished Florence – Kipper's Pie, and the Mont of his wartime letters – quite suddenly died. Graham and Mary never quite knew what happened, and Kipper – in this he was very like his father – offered no details. Apparently Florence went into hospital for an inspection that alarmed neither her nor Kipper; but a small explorarory operation was necessary, and during the course of it she collapsed. The unexpectedness of the tragedy was total; it was the third sudden, or premature

Holiday snaps, mostly of days
in the west country with the Gossages,
and including an impromptu waltz
by Shepard and Gossage senior.

Christopher Robin – a sketch.

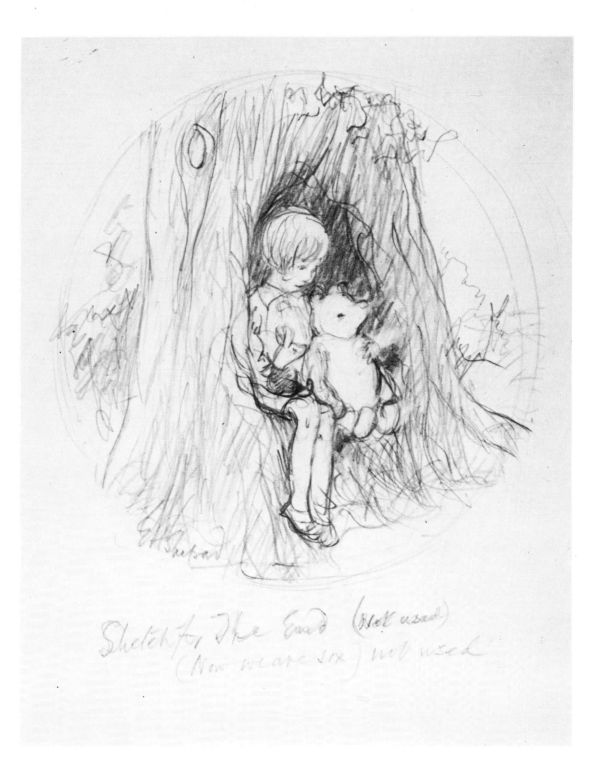

Suggested, but unused end piece for *Now We Are Six*.

death of a person close to him that Kipper had encountered in his forty-eight years, and the most poignant. He had first spoken to Florence in the Royal Academy Schools, when he invited her opinion of an oil painting he was working on – he spoke not only because she was a beautiful girl but because he much admired her work. He had relied on her encouragement and criticism almost from that time on; he always said she the better artist of the two. Now, just when Kipper and the style he had with such great pains developed with her unselfish help, were gaining wide acclamation, she was snuffed out. The 'children' (Graham was twenty and at Lincoln College, Oxford; Mary, seventeen, about to go to school in France) were at first lost. Kipper's answer, as you might expect, was work. In 1927 *The Little One's Log* by Eva Erleigh (Lady Reading) and *Let's Pretend*, children's verses by the wife of Punch's managing director, had been published with Kipper's drawings (both as the result of some influence, one suspects), and for the Christmas book season of that year he edited and decorated the *Punch* selection, *Fun and Fantasy*, as well as Milne's new offering of children's verse, *Now We Are Six*. Next year (1928) there was another book of verse by Lucas, Milne's *The House at Pooh Corner*, and Kipper's first illustrations for a Kenneth Grahame work, a new edition of *The Golden Age*.

The Shepards moved to Long Meadow in the summer of 1928. 'At first it was grim,' writes Mary. But they took with them two old female retainers, also 'Judy' (a Welsh Mountain Rambler bitch, according to Kipper, who gave birth to her last litter at the age of fourteen – disas- trously, after an afternoon's rabbiting) 'and my mother's spaniel and the cat.' At the wish of the senior retainer they took 'a small chestnut tree that my mother had planted from a conker . . . A former neighbour at Shamley Green said to my father, stuffily: 'I hear that you have moved to the Lamp Post area' – and we never saw her again.' The Shepards had certainly moved up in the world, judged by any ordinary standards, but I very much doubt whether Kipper had really noticed it. He was as much at home with the villagers of Shamley Green as with the solid citizens of the outer residential districts of Guildford. He had the 'Victorian' urge to improve his financial position by respectable hard work, but it never occurred to him, as it did to many Victorians, that he was morally better because he was richer; and he remained, as his family so often noted, much surprised at his success.

The
LITTLE ONE'S
LOG
Baby's Record
by
Eva Erleigh
(The Marchioness of Reading)

With Foreword by
Dr Eric Pritchard

Illustrated by
Ernest H. Shepard

The Library Press Limited
36, RUSSELL SQUARE, LONDON, W.C. 1

In Georgette Agnew's *Let's Pretend*
Shepard first tried out his beautifully
successful technique at silhouette.

In 1927 Shepard illustrated *The Little One's Log* for Lady Erleigh,
later Marchioness Reading. Over forty years after, he met her
again as the Dowager Marchioness, much involved in women's
associations, and designed this card for her.

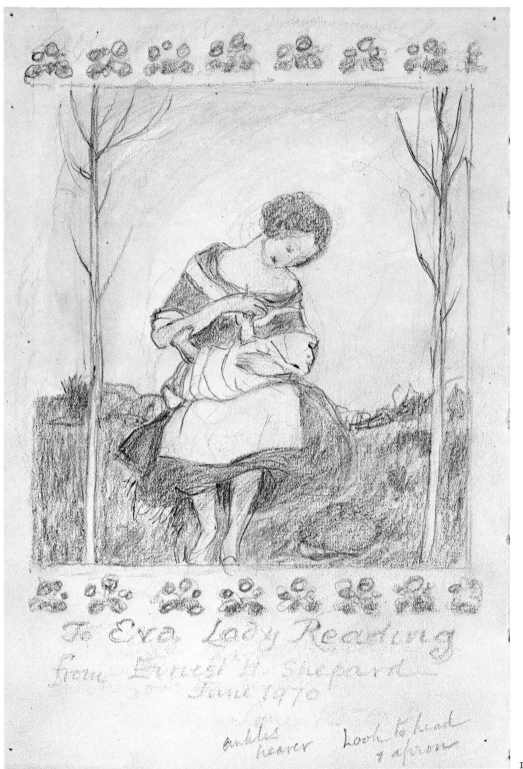

To Eva Lady Reading
from Ernest H. Shepard
June 1970

ankles
heaver Look to heal
 of apron

The 'thirties were for Kipper even more hectic than the 'twenties; he illustrated fourteen books as well as doing dust-jackets or frontispieces for others. They included some of his best black-and-white – in *Everybody's Boswell* (1930), Kenneth Grahame's *Wind in the Willows* (1931), Richard Jefferies's *Bevis* (1932), Jan Struther's *Sycamore Square* (1932) and Laurence Housman's *Victoria Regina* (1934). He also added twelve colour plates to his original drawings for a selection from Milne's two verse books, now called *The Christopher Robin Verses*. Kipper's constant need to be in London made using Guildford as a base too difficult, and he had taken a share of a house at 57, Cleveland Square, off Bayswater. The share was with Michel Salaman, who had been an art student with Kipper and was a continuing friend. Both Salamans and Shepards lived there in various rooms with varying responsibilities until, as Mary said, 'The house collapsed. I don't mean the building; the menage broke down from mismanagement.' By that time Graham, who had gone to work under Kipper's old fellow-officer Bruce Ingram at *The Illustrated London News,* had married a charming Canadian girl, Anne Gibbon (Anna to the family). Kipper bought them a house at 5, Melina Place, not far from the home of his birth in St John's Wood (Kipper was always faithful to old environment), and took a studio upstairs. For a time Mary lived there as well; the family was very much together. (Melina Place was hit by a bomb early in World War II, when Kipper took a flat and studio in Circus Road).

In 1932 E.V.Knox (Evoe) took over the editorship of *Punch* as Sir Owen Seaman retired, and three years later 'Raven-Hill was succeeded as second cartoonist by Ernest Shepard, who was rather wasted on the job.' (R.G.G.Price, op. cit.) Few would disagree with that judgment, and some might add that the job itself would have wasted most artists. It has often been said that Kipper 'could not get a likeness', and he himself has commented mildly on his failure as a portrait painter, though some examples in this book belie both judgments. Cartooning, however, is not portraiture. Kipper always liked to draw from life; was, indeed, rather lost if he could not. But he wasn't easily able to give the face in front of him a different expression from the one he saw. He had, however, been appointed second cartoonist, and, as with all jobs Kipper was given, he got on with it. Earlier he had drawn his first full page cartoon for *Punch* in May, 1932 – a late Spring, arriving at last. As a bright, topical idea, it was just about the nadir of what a *Punch* table could think up after a good meal, and it typified, I fear, the dying days of Seaman's regime. I don't believe that Evoe ever asked

It was a family that just loved dressing up. Shepard and his daughter Mary at Slade Art School Ball, when she was studying there, about 1930.

With *Victoria Regina* (1934) Shepard began a collaboration that led
to his illustrating a whole sequence of Lawrence Housman's plays.

A typical 'amusing' child jest,
enjoyed by *Punch* readers of the 1920's. April 1924.

Wind-blown ladies changing,
seen on holiday with the Gossages.

Shepard's first full page cartoon
for *Punch*, May 1932.

CAN SPRING BE FAR BEHIND? YES.

Cupid (as Call-boy). "GET ON WITH IT, MISS PRIMAVERA, OR YOU'LL MISS YOUR TURN ALTOGETHER."

Shepard's 1932 illustrations for Richard Jeffries's *Bevis*,
first published in 1913,
were among his most successful.

King George v's Jubilee, April 1935.

London telephone numbers used to be prefaced by three letters,
originally the first three letters of the district exchange name.
By the time Jan Struther published *Sycamore Square* (1932), the
opening of new exchanges had put pressure on this alphabet, and
Gulliver was invented by the Post Office to serve the Camden Town
area, because GUL happened to be going spare.

Right An office jotting.
The ever-busy printer with proofs.

156

Sketches for *Punch* drawings.

March 29 34

Dear Gwee
I send you this as I know
it is wanted urgently - I hope

it is all right
yours ever
E.H.S.

As with Milne's *Pooh* books, in Kenneth Grahame's *The Wind in the Willows* Shepard's pictured animal characters took over the printed page. Here again are Toad, Badger, Ratty and the rest. As with Milne, Shepard had the satisfaction of knowing that Grahame approved of his interpretation.

The Mole had been working very hard all the
morning, spring-cleaning his little home.

'This is fine!' he said to himself.
'This is better than whitewashing!'

'What's inside it?' asked the Mole, wriggling with curiosity.

The Water Rat . . . sculled steadily on.

'Now pitch in, old fellow!' and the Mole
was indeed very glad to obey.

'He'll be out of the boat in a minute if
he rolls like that,' said the Rat.

'Well, tell us *who's* out on the river.'

The Rat . . . hauled him out and set him down
on the bank, a squashy, pulpy lump of misery.

'There's Toad Hall,' said the Rat.

A gipsy caravan, shining with newness,
painted a canary-yellow, picked out with green.

At last he took refuge in the deep dark hollow of an old beech-tree.

The Badger, who wore a long dressing-gown,
and whose slippers were indeed very down-at-
heel, carried a flat candlestick in his paw.

It was a pretty sight,
and a seasonable one,
that met their eyes when
they flung the door open.

Knotting the sheets from his bed together . . .
he scrambled out.

They got the boat out, and the Rat took the sculls.

'Hullo, mother!' said the engine-driver,
'what's the matter? You don't look
particularly cheerful.'

He fetched tub, soap and other necessaries from the cabin, selected a few garments at random, tried to recollect what he had seen in casual glances through laundry windows, and set to.

First, there was a belt to go round each animal,
and then a sword to be stuck into each belt,
and then a cutlass on the other side to balance it.

The barge-woman was gesticulating wildly and
shouting, 'Stop, stop, stop!'

The four Heroes strode wrathfully into the room!

Kipper to do anything so banal as Primavera, for he did brighten *Punch* considerably when he took charge. Evoe's own life was also soon given a happy uplifting: in October 1937, after two years of sad widowhood, he married Mary Shepard at Guildford, and the couple were roisterously sent off from Long Meadow.

In the early 'thirties Kipper was greatly praised for his work on the Victorian boys' adventure book *Bevis,* by Richard Jefferies. It was a story that took hold of Kipper's always ready imagination, written 'when Swindon was a country town, and Coate Farm, where the boys lived, was surrounded by meadows, with Coate Water, the big lake, on the far side. The lake was the boys' unexplored sea . . . I believe the book had not been illustrated before Jonathan Cape asked me to do it in 1932*. I went there one day that year, and found farm and lake much the same as it must have been when Bevis lived there.' Kipper was none too soon, for with the rapid expansion of Swindon the lake shortly became an 'ornamental water' for the town. Even more satisfying for him, though, had been his collaboration with Kenneth Grahame on *The Wind in the Willows* the year before. In earlier editions the book had already been illustrated by three different artists, none of whom satisfied Grahame. Nor had Kipper, who of course knew the book well, thought much of them; indeed he believed that *The Wind in the Willows* was one of the books – he had a mental list of them, he said – that should *not* be illustrated. When he was offered the work he took it on simply because others had tried and he was sure he could do better. Grahame was not at all so certain; he had always thought Arthur Rackham to be the man, but Rackham had already once turned down the idea. (Grahame died in 1932, after which Rackham did illustrate yet another edition; but his drawings did not have the popular appeal of Kipper's.)

Kipper went down to Church Cottage in Pangbourne, Berkshire, where Grahame lived, to talk the old man round. 'My animals are not puppets; they always make them puppets,' was Grahame's constant refrain, and he told Kipper about his deep love of 'the meadows where Mole broke ground that spring morning, of the banks where Rat had his house, of the pools where Otter hid, and of the Wild Wood way up on the hill above the river, a fearsome place but for the sanctuary of Badger's home, and of Toad Hall.' Grahame was too old and infirm to take Kipper out and show him the river, as he wished, but Kipper went by himself and watched, and sketched, and swore he could have seen Otter rising from the water, and Badger on the bank. When he took Grahame his sketches the old man was happy. He had told Kipper: 'I love these

From Winifred Fortescue's
Perfume from Provence –
the streets of Nice
so narrow that lovers
could snatch a kiss
by leaning out of windows.

*He was wrong there. Harry Rountree had done colour pictures for the book in 1913.

Sketches for *Punch* drawings.

Neville Chamberlain's dropping of Hore-Belisha,
a beleaguered cabinet minister whose only claim to fame
seemed to be the marking of pedestrian crossings.
Punch, June 1940.

Country studies at Long Meadow.

little people; be kind to them' and Kipper was more than that, for as he said he was more excited at the prospect of that work than of any other he had undertaken, in spite of its immense difficulty. It is amusing to find Milne, in the introduction to *Toad of Toad Hall,* the play he beautifully fashioned from *The Wind in the Willows,* remarking that Grahame's story 'is not worked out logically. In reading the book it is necessary to think of Mole, for instance, sometimes as an actual mole, sometimes as such a mole in human clothes, sometimes as a mole grown to human size, sometimes as walking on two legs, sometimes on four . . . ' He was writing of course of the difficulty in putting Grahame's animals on to the stage, but it was just as hard for the illustrator, and, logical or not, Milne had mixed two real animals with a lot of toys in *Winnie-the-Pooh,* and Kipper had overcome that one. Kipper never forgot the excitement of the river by Pangbourne, and when Grahame died his widow Elspeth replied to Kipper's letter of sympathy: 'He liked you so much, and was looking forward to your coming here during these summer days when the river and garden are so beautiful . . . I wish I could see you sometimes – for I do feel there was a bond between you besides that of your united work.'

Victoria Regina (1934), by Laurence Housman, was Kipper's last major undertaking in the 'thirties, though he put a lot of work into Winifred Fortescue's *Perfume from Provence* the following year, and in 1937 illustrated three books including the unlikely *Cheddar Gorge,* a book on cheeses edited by Sir John Squire. As World War II so obviously and inescapably approached, Kipper viewed the prospect with none of the enthusiasm he had shown in similar circumstances a quarter of a century earlier. Graham who, like his father, had always 'messed about in boats', was in the RNVR and was duly called up in 1939. Anna and her little daughter Minette, Kipper's only grandchild, soon departed for Canada, taking with them Growler, the original of Winnie-the-Pooh ('a magnificent bear,' said Kipper. 'I have never seen his like'), who had been passed on by Graham to his daughter. Growler met his end in Canada, savaged by a dog. Mary and Evoe had moved to a flat just north of Regent's Park, not far away from Kipper's London perch, but they were not always available. As the war started Kipper was probably more bereft of family than he had ever been in his life.

Minette,
Shepard's grand-daughter,
with Growler,
the long-lived Teddy Bear
who was the model
for Winnie-the-Pooh.

Ernest and the Punch Table

by H.F. Ellis

*H.F. Ellis, who was the Assistant Editor of Punch,
grew to know Ernest Shepard at work and formed
a friendship that lasted as long as the artist lived.
He recalls memories that extend
over almost a quarter of a century.*

Ernest and the Punch Table

To a recently recruited member of the Punch editorial staff in the early 'thirties Wednesday had a special significance. There were giants about – not necessarily visible giants, for the weekly luncheons at which the Table conducted its private mysteries took place on the first floor at No. 10 Bouverie Street while the editorial offices were on the second, but heard presences at least. Around 12.45 p.m. there arose an unwonted stir, almost amounting to a bustle, voices drifted up the stairs, a laugh that might conceivably be E.V. Lucas's, a casual 'Hello, Bernard!' that ranked, to an outsider, almost on a par with calling Zeus 'old boy'; and sometimes a figure, bound for a wash or a word with the Editor, would be momentarily glimpsed through my open door. Could it be Ernest Shepard?

Raven-Hill, I think, was the first of these Wednesday demi-gods who actually addressed me. He was then the 'junior' political cartoonist, whose weekly drawing appeared on the third page of the paper, Sir Bernard Partridge of course being responsible for the senior cartoon which had pride of place in mid-issue and was moreover blank on the reverse (as being, I suppose, something that you might like to cut out and frame). It was rage that drove Raven-Hill to seek my company one day when the Table had been in session for perhaps a couple of hours. Red-faced and redolent of claret he stumped into my office, leant so confidentially across my desk that a connoisseur might have been able to name the actual vintage and, without preamble, said 'Bloody fools, those people down there!'. Then he stumped off again to rejoin his peers.

These memorable words gave me a misleading impression of the normal conduct of affairs at the Table. Raven-Hill, unlike most if not all of his colleagues, had strong political convictions; and this, coupled with increasing deafness which sometimes led him (so E.V. Knox told me) to argue passionately against some proposal abandoned half-an-hour ago by the rest of the Table, occasionally drove him in fury from the room. With his departure (permanent) in 1935 a long calm descended on the Table's deliberations. Nobody, in the thirty-odd years of my own attendance at these luncheons, which began soon after Raven-Hill's retirement, ever walked out for any reason more emotional than to check a quotation from *Alice in Wonderland* or answer a demand of nature.

Least likely of all to display resentment of any kind was his immediate successor as junior cartoonist. An unruffled serenity was Ernest

National Registration Day – Sir John Anderson had suggested that the day everyone signed on to get identity cards should be treated as a festival. December 1938.

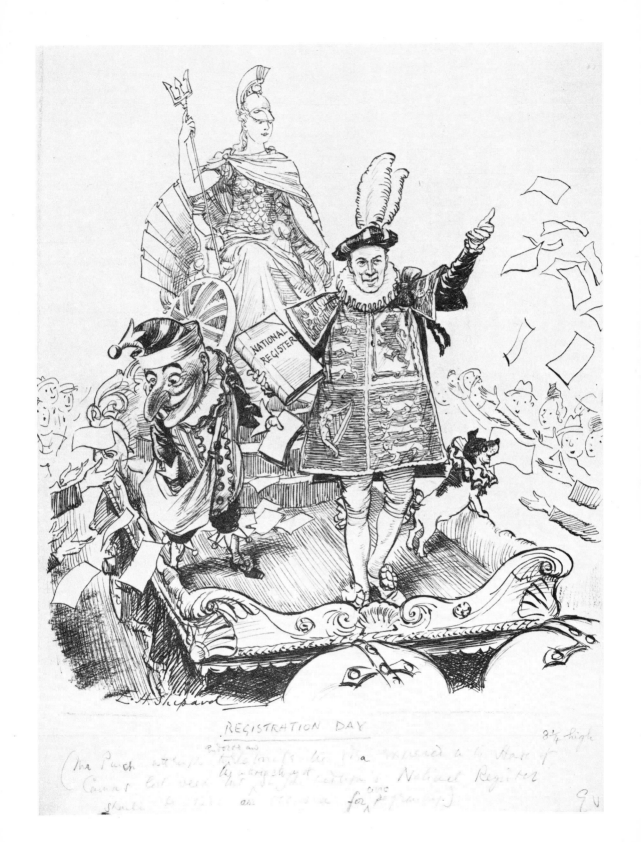

REGISTRATION DAY

8¼ high

(Mr Punch attempts ... his ... a Hall of
... National Register
... ... for ...)

9v

Shepard's outstanding characteristic. Equable, amiable, a little remote, he seemed to me as I came to know him at the Punch office and later away from it a very enviable sort of person. He was of course an established 'success', and success is a useful aid to equability. His illustrations to A.A. Milne's Christopher Robin and Pooh books in the 'twenties had brought, and continued to bring him a pretty income, so that he must have been, I should guess, easily the most materially secure among the artists and writers who were his colleagues. He gave himself, however, no airs on that score; no trace of the arrogance or smug pomposity that sometimes diminish the successful man was discernible in Ernest Shepard. To a newcomer at the Table, aghast at the mere idea of drinking soup within range of so patently august a figure as Sir Bernard Partridge, Ernest's easy friendliness was a most welcome and refreshing tonic for the nerves.

The job of Punch cartoonist was itself, in several ways, an enviable one. Attendance at the weekly meetings could hardly be described as a chore, for these were almost invariably, at least in peacetime, pleasant occasions. The luncheon, during which no work was done, was good. The Piesporter that almost always accompanied the earlier courses was excellent, and with the claret and brandy that followed few of us could find fault (though Alan Herbert, always a reformer, thought that the brandy bottle should be left on the table after the initial glass had been served). There was much random conversation, often not without wit, at times positively hilarious. E.V. Lucas, who claimed that he liked to sample every possible human experience at least once, generally had some curious encounter to relate; Alan Herbert, lately become Independent Member for Oxford University, would throw in some titbit from the House and soon swelled the ranks of those who thought they could mimic Winston Churchill; George Morrow – if you could hear what he said, which became increasingly difficult as his voice sank diffidently lower and lower when he found that somebody was listening – had a fund of improbably funny stories; E.V. Knox, from his Editor's chair at the head of the table, was wryly amusing and would carry on a conversation in his curiously oblique way with what seemed like a series of non-sequiturs but turned out, if you were quick enough, not to be; Sir Bernard Partridge – who, after all, had worked on the paper since 1891, overlapping by ten years the fabulous Tenniel whose connection, in turn, dated back to the 1850s, so that it was like lunching with W.G. Grace or a man who had been on familiar terms with the Duke of Wellington – Bernard lent an air of timeless distinction to the proceedings, relieved by an occasional quietly interjected remini-

Hitler and Mussolini, and Tojo as a dragon.
February 4th, 1942.

An idea for a Nero sketch, on which Shepard had doodled,
showing considerable word power.

scence; and Ernest Shepard (even *he* had his first drawing in *Punch* in
1907, the year the newest member of the Table was born) smiled
benignly on the company and talked, given the opportunity, of his
garden. All was agreeably relaxed and sociable.

Two cartoons, however, had sooner or later to be chosen, and to this
grave task the dozen of us thought necessary to achieve it (as compared
with a total working editorial staff, at this time, of four) eventually
bent our minds. The Editor began by indicating what he thought to be
the most important topic or topics of the week, or rather what would
probably be important *next* week when the paper came out. Discussion
followed. Alternative topics might be put forward, not always notably
topical; men have hobby-horses, Alan Herbert not least, and like to
ride them. Suggestions for the treatment of a likely subject were made,
the search for a 'formula' that could result in an amusing or arresting
picture seeming sometimes more important than the actual topic or the
paper's attitude to it. E.V. Lucas might be seen examining his loose
change, which meant that he was going to try to work in the seated
figure of Britannia. Artist members drew quick roughs, not always
entirely apposite, and passed them round the Table. George Morrow,
I remember, prompted by some chance reference to fish manure (and
perhaps to please Lucas), once dashed off a sketch of Britannia, armed
with bucket and shovel in place of the customary trident, in hot
pursuit of a shoal of mackerel. With such alleviations the precise form
of the senior cartoon was worried out, and we then turned our atten-
tion to the junior. Here the same procedure was followed, except that
it was usually much less protracted – if only because an idea discarded
in the earlier discussion would often be found to serve for this less
portentous offering.

In all this the cartoonist themselves took no very prominent part,
awaiting their fate with studied calm. Bernard Partridge, in particular,
said little, confining himself as a rule to brief interventions designed to
steer the debate away from any proposal that threatened him with too
many figures. His ideal was a cartoon limited to two characters,
preferably of about the same size; whether they were a Samurai
warrior and the Russian bear, or Neville Chamberlain and M. Daladier,
concerned him little. Ernest involved himself rather more, contribut-
ing roughs when a subject took his fancy, and always of course
placidly ready to have a go at whatever task was thrown at him.
Neither of them, to my knowledge, ever flatly refused to carry out the
Table's assignment, though Bernard Partridge had his own way, by

'Parent's Treat' from *Punch*.

The Parents' Treat

(From "The New Book of Moral Maxims," revised for 1928.)

WHEN Parents have been very
 good
And promised not to make a
 Noise.
And Done precisely as they should
 About the Christmas Toys,

A certain Licence, we presume,
 Can be permitted them: they may
Come down into the Drawing-room
 And Watch the Children play.

And if they Recollect when there
 The Lessons taught them long ago,
To Keep quite Still upon the Chair
 And Read a Book, or Sew,

They can be asked to Come Again:
 But if they Move a Hand or Foot
And Talk and Fidget or Complain,
 They will be told to Scoot.

How Greatly is the Household
 Blessed
 Where Children Romp and make
 a Din,
While Silent Parents, neatly dressed,
 Sit down to Listen-in!

Evoe

WEST ELEVATION

From the S. N. ELEVATION

Animal studies –
experimental
and conventional.

Shepard and his wife Norah, at Woodmancote in Sussex.

signing a drawing 'B.P.' instead of with his full name, of showing that he didn't think much of it.

To the ordinary contributor, racked weekly by the need to excogitate an idea for his article or illustration, the cartoonist, with his week's work handed to him on a plate along with the free salmon mayonnaise, seemed to be on velvet; and a short week's work it was too, since a start could not be made until after the Table broke up around tea-time on a Wednesday and the finished drawing had to be at the printer's by noon on Friday at latest. Ernest, in fact, often brought his cartoon round from his London studio to the Editor's house on Thursday evening, after which he was free for five clear days to enjoy his Guildford garden and to work at other kinds of drawing better suited, it is fair to say, to his talents.

Of course there were drawbacks to the job. Artists, like writers, prefer (in the modern idiom) to 'do their own thing', or at least to do the given thing in their own way. As a lifelong illustrator Ernest was used enough, no doubt, to limitations of subject, on *what* to draw; but *how* to do it – when illustrating *The Wind in the Willows,* for instance – would be his own affair. There was precious little scope in *Punch* cartooning. Caricature was not, by tradition, indulged in, and the drawing of 'likenesses' (even if you are good at them, which Ernest was, on the whole, not) can pall, particularly when Ernest or Hitler crops up for the twentieth time. Add the paper's conviction of the *importance* of what its cartoons were trying to say, and it will be seen that the artists' opportunities for self-expression, spontaneity, strong satire, or even just fun, were few and far between. Daily cartoonists like David Low and Strube worked in a different world. They were daily, for a start, and could be reasonably certain that the topic they chose would be topical when their drawing appeared. On *Punch,* working always for a week ahead, we were haunted by the spectre of some disastrous development after the cartoons had been finally put to bed, and this fear in itself tended to weaken, to make more tentative, what we wanted to say. Hitler, with his habit of invading countries at the week-end, was constantly disconcerting. Edward VIII shilly-shallied unforgivably over his abdication, presenting the Table on Wednesday December 2 1936 with the task of constructing a cartoon that would cover the practical but not absolute certainty that he would be gone by our publication date of December 9. It was decided to show him at the foot of steps leading to the empty throne, and poor Ernest (for Bernard somehow contrived to wriggle out of the assignment, securing

After he had ceased cartooning for *Punch*, Shepard's work for the paper was mainly delicate illustration (*see also page* 195). March, 1951.

BASSO DA CAMERA

"AND this is my Ruggierius,"
 the collector said.
"Isn't it a wonder! Isn't it a beauty?
Preatoni brought it from Italy."
He shook his head.
"Some people hint it is just a touch too fruity.
See . . . it has the flat back of double-basses:
only the 'cello is round-backed,
only the 'cello.
But look at the belly."

His fingers traced the wavy
faint lines of the graining.

"Mellow, ah, rich as gravy,
Cut 'on the slab,' d'ye see,
as the old way was:
look how the grain slants . . . the varnish, clear as
 glass.

Now look at my Gaspardo:
that was cut 'on the wedge.'
A tree is round: so, cutting in wedge-shaped pieces,
you get the grain-line perfectly straight,
d'ye see?
Ah, the Gaspardo!"

Lightly he touched the edge
of the purfling.

"Three, only three Gaspardos are known,"
said he.

"One is in a museum, a museum in Venice;
one another collector has; and this is my own:
he's the portliest of aldermen for a certainty,
Gaspardo. But Gog, here, he's the Lord Mayor at
 least,
or a mitred abbot.
My basso da camera.
Amati. Dragonetti's own instrument—
and I've got the bow
Dodd made for him, Dodd, of Sheffield, in, let me
 see . . .
yes, just a hundred and five odd years ago
when Dragonetti—oh, he was the maestro!—
was eighty-three
In eighteen forty-six."

With resinous fingers he picked up the bow,
and drew
its elegance sliding across the Amati's strings,
and the air and the room vibrated in one full chord.

"Beautiful; isn't he beautiful?"
he said.
"Of all my big fellows, my fiddles,
this is my pet.
Dragonetti's own instrument.

Now, he was the one
who persuaded Beethoven to write bass parts."

His head
shook again sadly.

"Oh, the thumps that he gave to my beauties!
I wish Dragonetti and he had never met."
 R. C. SCRIVEN

Shepard accepting hospitality on one of his many visits to France.

instead for himself the straightforward destruction by fire of the
Crystal Palace) was asked by the Editor to make the King look, if
possible, as if he had just descended from the throne or might, on the
other hand, be just about to ascend it again. Even Ernest muttered a
little at this, while Bernard assumed the air of a man who could easily
have done it himself, had he been so inclined. (The cartoon was, at the
last possible moment on the Friday, entitled 'Hesitation' and just
about got by. It was on December 10 that Edward sailed for France).

Ernest soldiered on as cartoonist through the War years, and it was
only after Knox's retirement in 1949 that he was relieved of a surely
not very congenial task. The new Editor, Kenneth Bird, decided that
one cartoon a week was enough and that it should be entrusted to
Leslie Illingworth, who had joined the Table as second cartoonist on
Bernard Partridge's death in 1945. Ernest was thus set free for the
illustrative work that seemed his natural bent, supplying month by
month new head-pieces, of admirable invention and quality, for the
opening page, and often a framework such as only he could design for
the verses that now appeared on the centre page once sacred to Sir
Bernard. Occasionally, too, he provided the drawings for a kind of
reporting that *Punch* tried in the early 'fifties. I remember, when we
went up to North Norfolk together to 'cover' (as we journalists say)
Territorial Heavy and Light Anti-Aircraft Batteries at their practice
camps, how excited he was, in his quiet way, to be with guns again. He
never forgot his service with siege and medium artillery in the Great
War, both in France and in Italy, and he loved to talk about OPs and
bracketing and more modern systems of fire control – surprising as that
may be those who think of him only in connection with Pooh Bear and
Mr Toad. He must have been, I should guess, the sort of reassuring,
unflappable battery commander under whom men like to serve.

There were other expeditions too, unconnected with work and some-
times in considerable strength, for after the Second War, when the
Table had been reinforced with younger men like Eric Keown and
Bernard Hollowood, we kicked up our heels once in a while and sallied
out for pure enjoyment. It was in the summer of 1947 that seven of us,
tired of the dismal rations of that phoney peace, decided to go over to
France for a decent meal. Our goal was *Le Cygne* at Tôtes, about twenty
miles inland from Dieppe, an inn of two-rosette Michelin rating and
patronised not so long before by such transient customers as Rommel
and von Rundstedt. Our route was by sea and Ernest, having seen the
S.S. Worthing safely out of Newhaven, inspected the engines and

(*Right and below*)
Punch was trying
to liven up
a rather desperate
jokes column,
Charivaria,
with decorations by Shepard.

PUNCH

OR

THE LONDON CHARIVARI

Vol. CCII No. 5274

April 1 1942

January, 1951.

COUNTRY KITCHEN

SMOOTH shelves, standing high,
 lined with light, a dapple-gleam
by grave oak caught from sky
 with leavy hands, now bound in beam;
broad of base, firm of foot
 as trunk of tree stands, wind-square,
steadfast with grappled root:
 bright with brass and china-ware
the crone-brown dresser, flame-tinselled high,
drowses in dream of days long by.

Huntsman with horn and coupled hound
through wide wood riding on the stone-jar's round:
 how on the hill where the day lay green
 the heart leapt high as the scent struck keen!
Dancers lithe in lustre-gold
hand to hand in their love's close hold:
 how in the morning the heart grew light
 dancing again through the memoried night!
Shakoed swordsman, booted, spurred,
reining his courser, clarion-stirred:
 how through the long year the heart told, slow,
 of hope that would bring what fear saw go!

Muslined maidens gathered for the bidding;
bride and groom in the mounted wedding
 highway-hastening, loose of rein,
 never to ride apart again!
Cups for the christening; finery from fairing,
ram under thicket, spaniel staring,
 shepherd piping, gipsy roaming
 seated by stream, her dark hair combing:
laughter that sang and grief unspoken
left in litter of trinket-token.

Tall in shadow, dark with days,
the lean clock mutters—*nothing stays*:
 memory-piled where the fire-glaze gleams
 the crone-brown dresser counts its dreams.

Tree in China by the angle-armed pagoda
 leaning by the lake where the oared boat plies,
loving by the bridge where the flower-soft odour
 lingers round the lovers under bar-cloud skies.
Wing to wing the doves fly, fanning at the sun,
 hand in hand the lovers wait beside the gate:
love is never dying, day is never done:
 love like the tree stays, patterned on a plate.
 ALUN LLEWELLYN

generally satisfied his intense affection for ships and the sea, soon became curious about a kind of cone or windsock flown from the mast-head. We went up on the bridge to solve this mystery – you could reckon that any party with Herbert, by now Sir Alan, in it was free to go anywhere – and put the question squarely to the captain. Was it, somebody suggested, to record the direction, or perhaps rather the pressure of the wind? The captain said no, it was to catch beetles. He said the air in mid-Channel teemed with insect life, and it was his custom to send all the beetles, spiders, lady-birds etc that he caught as he went to and fro to some scientific body at Oxford, who were investigating the migratory habits of these creatures. Ernest, who had a boyish enthusiasm for the out-of-the-way, was entranced by this addition to the lore of the sea and asked the captain how he could tell whether the beetles were inward or outward bound when he caught them. A good question, which remained, I think, unanswered. Captains get called away to mind the ship at times.

I have a snapshot taken in the courtyard of *Le Cygne* during this trip – and taken, I should say, judging by the comparatively healthy looks of the party, on the afternoon of our arrival rather than the morning after that memorable dinner – which shows him standing, cigarette in hand (though a pipe was more characteristic), close up against Mlle Richard, the hotel proprietor's attractive daughter, and wearing a smile of absolutely irresistible proportions; no photographic grimace this, but evidence of a happy man's enjoyment of any fun that life has to offer. There is other evidence too – not from the camera's lens but from his own inventive mind and hand – of his relish for this kind of off-the-cuff frolic with friends.

Our departure from Tôtes on the morning after had been a somewhat shambling and disorganised affair, with general agreement that Calvados ought to be taken more seriously in future, if at all, so that it was no great surprise when our hired bus was overtaken by a wildly hooting car bearing Mlle Richard and a quantity of forgotten items, including Bernard Hollowood's shaving things and an odd sock or two. It was this trifling incident that Ernest chose to commemorate in a water-colour drawing that perfectly enshrines the occasion, our enjoyment of it and the consequences, the characters involved, and – incidentally – his own highly personal gift for blending fact with fancy. It is a fantasy that, to one old man at least, is almost tearfully evocative.

The famous *Punch* staff expedition to Dieppe –
famous that is, to all who took part in it –
as Shepard saw it. 1947.

Punch Table
Dinner.

October 26th 1960

To Honour

E. V. Knox Esq.

E. H. Shepard Esq.

Sir Alan Herbert

P. G. Wodehouse Esq.

In the Chair

Alan Agnew Esq.

Alan g Agnew
LESLIE ILLINGWORTH

E. V. Knox

Christopher Hollis

Ernest H Shepard
Richard Mallett

Eric Keown

Norman Mansbridge

David Langdon

H. F. Ellis

A. P. Herbert

Russell Brockbank

Ernest and the Punch Table

Agelessness, during all the years I knew him, was one of Ernest's most remarkable gifts. In October 1960, when the Punch Table held a special dinner to honour four men who had been contributors to the paper for a span of fifty years and more – E.V. Knox, Alan Herbert, Ernest Shepard and (*in absentia*) P.G. Wodehouse – he seemed to me to be exactly the same poised, contented, quietly genial man who had paced the deck of the beetle-haunted S.S. Worthing in 1947 or, for that matter, who had made a newcomer feel at ease at the Table in 1936. It was inconceivable that he should be over eighty. And nine years later, although he did caution me, in a reply to some birthday congratulations, 'Don't ever be 90', he added a sentence that showed he had not really changed. 'I am keeping,' he wrote, '*one* Greetings Telegram – from the Master Gunner and all ranks RA'. This gentle artist was a soldier to the end.

Fighter Cover

CHAPTER 6

1940-1955

War again –
and regeneration

With publishing at a standstill for the duration, Kipper could expend his energies only on *Punch,* and newsprint was so short that he could find no room for any extra work there. Afterwards he used to say that he enjoyed drawing cartoons of Hitler and giving him an evil face, but, week after week, it must have been a constricting task. John Jensen, the well-known political cartoonist, has pointed out that *Punch* tradition still closely confined the cast of characters which might appear in its cartoons, and even the situations arranged for them recurred again and again. In a 1974 exhibition of one hundred Shepard cartoons, held at the University of Kent, Jensen notes that 'there are ten or so young ladies representing Britain, France, the League of Nations, the United Nations and others. John Bull makes a modest five appearances.' Six ideas are taken from Tenniel's 'Alice' illustrations, and ten from either Dickens, Gilbert and Sullivan, nursery rhymes or folk-lore. 'A further six drawings show the carrying of loads upon inadequate shoulders, or the pushing and pulling of burdens in wholly insubstantial vehicles.' Yet, Jensen concludes, 'Shepard moved from strength to strength, . . . increasingly able to impose his quiet humour on otherwise grim and humourless topics.'

The first winter of the war was the worst for him, with little excitement and not enough work. Only after France had fallen, and the church bells of Britain were silenced until either invasion or victory, could Kipper begin to call it a war. He was over sixty now, but as energetic as ever, and when the Home Guard was raised he was very soon commanding a company outside Guildford, resuming his substantive rank of captain. Often he did duty four nights a week in the interval between producing his cartoons for *Punch*. The 1941 winter blitz on London temporarily interfered with his Guildford soldiering. Bernard Partridge's house had been bombed and the senior cartoonist had to move out of London, so Kipper took his place. He lived mostly at Melina Place until that was bombed, and then at Circus Road, limiting his journeys down to Surrey because of the uncertainty of being able to return on time. But Partridge was able to get back to London in 1943, and Kipper could again spend more time at Long Meadow.

In May that year Graham, at sea on the corvette *Polyanthus,* wrote to his father: 'Our news is brilliant – so good I hardly dare mention it for fear something should go wrong at the last minute. It seems impossible one should go on being lucky *all* the time.' Presumably he knew he had a chance of leave, for in August he turned up at home for a brief furlough. Kipper was of course delighted – father and son always got on

'Artist at work'. Shepard in France again.

wonderfully well. There were parties at Long Meadow, where Kipper somehow managed to keep open house at week-ends throughout the war. He was a familiar sight carrying his shopping bag, standing in queues to collect the rations, and somehow he managed to defeat the system, or at any rate to get hold of plenty, without cheating – no friend was ever sent away from his house without a meal or a drink. Graham's leave passed quickly. He disappeared again into the silence of censored letters, and six weeks later Kipper was informed that *Polyanthus,* escorting a large Atlantic convoy, had gone down with Graham aboard. This time there was not even enough work to use as a pain-killer. Once again Kipper said nothing to anyone, except to Mary who nursed an equal sorrow, and simply carried on. When later he wrote those recollections of his youth he showed how deeply he felt the loss of his mother and his brother – enough time had passed for him to be able to express his misery in print. But his immediate outward reaction to grief was to ignore it completely. That was how he had been brought up to behave. Two matters properly brought-up Victorians did not discuss were private grief and affairs with women.

It so happened that at this particular time Kipper was having an affair, and it may be that it helped him. It would be absurd to suppose that he had led a totally monkish life since his wife died in 1927. He much admired women, and they were frequently attracted to him. He never had any difficulty in getting female models – which is not, I need hardly say, to suggest that every girl who posed for him became a lover; that is the outsider's hazy view of the art world. But he was human enough, and had a few discreet affairs, and his current girl friend was a nurse working at St Mary's Hospital, Paddington. He had met Norah Carroll at a hospital concert he attended. They had been lovers certainly since May, 1943, and the liaison was just as quiet and disciplined as any other of Kipper's had been, with this difference: Norah was firmly determined that he should settle down again. Anna, who came back from Canada with Minette when Graham was killed, expected to stay in England and keep house for Kipper. Abruptly he broke the news to a surprised family that he was about to marry again, and in November he took Norah as a bride in St Marylebone Church.

The outsider might see something almost ruthless in the way Kipper went about getting what he wanted – yet that is quite an impossible adjective to apply to him. Minette has described how, when he was working at long Meadow, the whole house revolved around him; on no account was he to be disturbed, whatever was happening to anyone

Shepard, early in World War II, with his son Graham,
commissioned in the RNVR.

Sketches for wartime cartoons. *Punch*, May 31st, 1944.

Studies of girls.

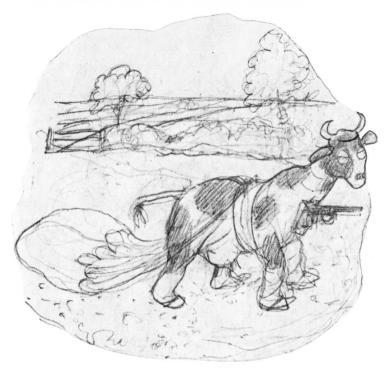

Shepard's Home Guard nightmare.

Wartime Christmas on the Italian front.
Punch, Dec. 1943. An echo of a Greeting in 1919
(*see page* 98).

else. She was allowed, as a small girl, to take coffee upstairs to him in mid-morning, and she was supposed to leave at once. 'But I stayed often, and watched him drawing, because – though he didn't say any-thing – he didn't seem to mind. No one else was allowed to come near, though.' He ran his life, both in and out of the house, to suit his work, and would have been genuinely surprised to hear that any arrangements of his had inconvenienced anyone else. I doubt that he ever did so hear; they were all too fond of him. Anna says: 'He was a perfectionist. He always said that to be a good artist you had to work all the time, and it was almost a disease.' Also, Kipper quite simply believed that any gift he had came from God.

Marriage did not interfere with his Home Guard activities. In August, 1944 he writes to Norah about an exercise: 'The battle this morning was a terrific affair.' A two hours march to the location and another two hours of preliminaries, and then 'the battle was fought from every point of the compass, gave me plenty of running about and climbing along ditches, and I *did* get hot . . . After a breather we marched back to the camp, hotter than ever . . . Cook house was already going so we had tea and put up tents (the sergeant-major and I slept in mine).' Simultaneously he was having trouble with a cartoon whose theme events had overtaken (the dreaded curse of *Punch*). 'My nymph is difficult to fit in to the present juncture – though I did suggest Rhine Maidens packing up and bolting. Rather a good subject would be rape of the Rhine Maidens by the *Maquis,* don't you think?'

When the war did end, there was no immediate flood of new commiss-sions for Kipper. The publishing trade was taking a little time to get back on its feet. The slackness of demand presumably accounts for one of the odder sketches in Kipper's notebooks – a formidable looking Gertrude Bell, sitting writing beside an open window that opens on to Arab scenery with mosque. Basildon Bond, the notepaper people, wanted a series of advertisements featuring famous women, and this apparently was the start – also the finish, as far as can be gathered, since there is no further mention of a contract. Not until 1949 did Kipper take on another book, and then it was to be *Bertie's Escapade* by Kenneth Grahame, the adventures of a pig that got loose from its sty at Christmas time. Kipper's illustrations held strong reminiscences of *The Wind in the Willows.*

In 1949 Evoe retired from the editorship of *Punch*, to be succeeded by Kenneth Bird ('Fougasse') who had been Art Editor. Kipper, as has

Basildon Bond, the notepaper people, had decided on an advertising
series of famous women at their desks and Shepard was to draw them.
This was Gertrude Bell – but the series was never commissioned.

Shepard's pigs in the raw and,
in print, pig clothed –
for Kenneth Grahame's *Bertie's Escapade*.

A *Punch* Almanac illustration
of E. V. Knox's verses.

The Pirates
(Timothy's Wonder)

I've asked a great many people,
 But nobody seems to know,
How the pirates kept their Christmas
 In the days of long ago.

How many loaded galleons
 On Christmas Day they sank,
And how many merchant seamen
 They made to walk the plank.

Or whether they chanted carols
 As round the decks they rolled,
And made each other presents
 Out of their hoards of gold;

And covered a mast with green leaves
 And called it a Christmas-tree,
And hung it with shining sequins
 On the shore of a tropic sea;

And lit the rum round the pudding
 And cursed in a kindly way,
But refused to do any business
 Because it was Christmas Day.

I've asked a great many people
 But nobody seems to know,
How the pirates kept their Christmas
 In the days of long ago.

Evoe.

been said, ceased to be a regular cartoonist. Nevertheless he carried on with *Punch*, and in the meantime illustrated some not especially distinguished children's books. In 1953 Malcolm Muggeridge took over from Kenneth Bird. Muggeridge had been hired straight from the *Daily Telegraph*, obviously with the idea of giving *Punch* a new look. Kipper's disadvantage was that he was just about the last artist left on the paper who drew the classical line. It is true, as Price wrote, that when Kipper started to draw for *Punch* he made everyone else look static; by 1953 everyone around him was moving in oddly comic directions, and he was left looking beautifully still. The idea of conveying humour through distorted line instead of the written joke was not new – not by a couple of centuries – but there had been a surge of such practitioners in the 'thirties, who made such old *Punch* experimenters in distortion as Bateman and Fougasse look positively orthodox. Evoe had hired Pont in the 'twenties, against opposition within the paper, and then David Langdon, whose wit was so quick that he often sent in enough jokes (of his own) in one week to fill the whole magazine. But there was still resistance. When, just after the war, I took Ronald Searle along to see Evoe and Fougasse, they turned him down. Muggeridge now, at great expense, took him on. The new editor was going to make changes. One of his first was to sack Shepard.

At least that is what Kipper always said; and since he did cease to be a member of the staff, it is probably true. His last political cartoon, on the Austrian peace treaty, appeared in September '52, though he did contribute a special one, for a World Churches' appeal, in the December of the following year. For one who had been a staffer for over thirty years, it was a wrench, and the parting does not seem to have been amicable. Norah, writing later to Kipper while she was in New Zealand, and replying to his news about the sad early death of Eric Keown, who had been with him on *Punch*, went so far as to say that it seemed unfair that he should be taken while 'that snurge Muggeridge' still survived. However, emotions cooled, and during Kipper's later years, when both men lived in Sussex, they met each other off and on.

Kipper's reaction to his dismissal was typical. In 1954-55 no fewer than nine books were published with his new illustrations. They included Mrs Molesworth's *Cuckoo Clock,* Eleanor Farjeon's *The Glass Slipper,* and Susan Colling's *Frogmorton*. For Mrs Molesworth's book Kipper had a problem, which he solved with his usual common sense. Cuckoo clocks are no longer fashionable, and to his dismay there was not a single one to be found in the Victoria and Albert Museum, though

The Austrian Peace Treaty.
Shepard's last political cartoon for *Punch*, Sep. 1952.

The Ugly Sisters from
Eleanor Farjeon's *The Glass Slipper* (1955).

An appeal for the World Churches.
Shepard's last full page cartoon
in *Punch*, Dec. 1953.

217

From *Frogmorton* (1955) by Susan Colling.

someone there thought there might be some in the Clerkenwell Road.
Kipper went out and put this minimal information to a London taxi
driver. It was quite enough. He was driven forthwith to a shop full of
cuckoo clocks in the Clerkenwell Road.

Though Kipper had not completely finished with *Punch* yet, the break
had undoubtedly given him a new lease of life. He was thinking of new
things to do, he broadcast talks, he gave lectures. With Norah he
started a series of travels to places more distant than his usual European
haunts. His second marriage was undoubtedly proving good for him.
Norah was immensely proud of him, she was a natural organiser, and
she saw that he entered fully into the local social round, which the
gregarious Kipper was happy to do – he had been a bit lazy about it
while he was alone. Norah, it must be said, did not get on with the rest
of the family, and not much attempt at conciliation was made on
either side. Kipper, if he noticed any coolness, ignored it; to have got
involved in any family differences would undoubtedly have been bad
for art.

1955-1976

The unfading old soldier

There was no slackening in the pace of the work Kipper had set himself, and in 1956 he did original work for as many as seven published books, more than in any other one year since he began his profession; he was also preparing the first of his books of reminiscence, *Drawn From Memory*. Among the others, 1956 saw fresh editions of *Tom Brown's Schooldays* by Thomas Hughes and *At the Back of the North Wind* by George Macdonald. Kipper had created pictures for the Hughes classic over half a century earlier, but now he went back to Rugby to redraw the school's main gate and wander about its grounds. *Drawn From Memory* appeared in '57, and also in that year eight new full colour plates for an edition of *The World of Christopher Robin,* one of the many 'combination' books of the Milne-Shepard fantasy now to be produced to keep up with the demand for Pooh and all about Pooh. The flow went on uninterrupted despite the complete move of house and studio from Surrey to Sussex. Norah had for some time wanted to move further away from London, or perhaps just to move from a house that was very much associated with Kipper's past, and now that he was no longer tied to *Punch* and had given up his London studio-flat, there was no good reason to hold him to Guildford except his love of the north downs and the river Wey. They moved to Woodmancote, a biggish house with a good garden, at Lodsworth in West Sussex. They transplanted their belongings slowly (Kipper never threw anything away) during the year 1956–7, while Eustons Salaman, the architect son of Michel, directed the considerable alterations to Woodmancote. Kipper himself, in the middle of all his other work, concerned himself keenly in the new house and in his sketchbooks are numerous details of parts of the new flat that was being built for the staff over the stables and interiors of the main building, even curtain hangings.

Drawn From Memory was a fair success, which was later to go into several paperback editions. Kipper was immensely pleased at this public acceptance of stories which he had told again and again to his children since the time when they were interested enough to listen, and he was encouraged to prepare a sequel. He was now, at the age of eighty, launching out on a new career as a writer and he took, if possible, more care over *Drawn From Life* than he had over the earlier work. In April 1958 Bernard Hollowood, now editor of *Punch* (he had been taken on by Evoe, and had survived Muggeridge), accepted a longish, fully decorated piece by Kipper on a trip up the Amazon he had taken with Norah. This, after all those years, was the first time he had ever written anything for *Punch* – and it was to be the last. In July Alan Agnew, *Punch*'s managing director, asked Kipper to come and see him and then agreed

From *At the Back of the North Wind* (1956)
by George Macdonald.

View of Chantry Woods,
from Long Meadow.

The garden pool at Long Meadow.
Shepard did this oil painting
and this water colour
shortly before leaving his
old home near Guildford,
probably as mementoes to take
with him. Somehow, Kipper was
always a gunner in his landscapes,
and you can feel him using
Long Meadow as an observation
post on Chantry Woods.

224

Tom and Flashman fighting,
from *Tom Brown's Schooldays* (1956).

to pay him a regular £300 p.a. (no time limit stipulated) which would cover any contributions to the paper Kipper might make unless their value, at the current 'piece-work' rate he was receiving, should rise over the figure of £300, in which case *Punch* would pay the balance. That was not a bad arrangement, at 1958 prices, for a man who had been sacked five years before, and argues that the *Punch* management had something of a conscience about the way Kipper had left. In fact, he did try one or two articles, which he would have illustrated, but Hollowood did not find them suitable, and no further work of Kipper's ever appeared in *Punch*. He was not going to start again on the old joke-and-picture business, which he had always found something of a strain, now that he had launched out into fully fledged authorship.

Also in 1958 Kipper turned down an earnest request from an American publisher that he illustrate a new edition of *Peter Pan,* a plea that was repeated but Kipper said he was too busy on his second book of reminiscences, which in fact did not reach print until 1961. Many would have thought *Peter Pan* the ideal subject for him, but it seems possible that Barrie's play was one of the subjects Kipper had registered as impossible to illustrate, perhaps on the grounds that anyone who had been exposed to that make-believe world in youth would have a very fixed idea in mind as to how it should look. Kipper's refusal is the more interesting in that soon afterwards he accepted an offer to do new pictures for Hans Andersen's *Fairy Tales* which – bearing in mind all those that had gone before – was indeed a challenge. The new Hans Andersen came out in the same year as *Drawn From Life* and contained some of the most charming later work of a rejuvenated Kipper.

It is hard to say how and when the public devotion to Pooh developed, as it did, almost into a fetish. The books had remained steadily popular, with parents as well as children, since they were first published in the 'twenties. Milne died in 1956, and the many tributes to him then revived interest in the works, but the publishers did not make any extra special advertising effort. Yet quite outside the book world, demand for reproductions of Pooh and his companions in the Wood grew and grew; toys, bath accessories, children's clothes were stamped with their likeness, boutiques and tea-shops were called after them – the cult grew especially in the United States. Walt Disney adopted Christopher Robin and his crew in 1965 – adapted them too. Linda Bird Johnson became a fan and in her father's first presidential term went on what was almost a diplomatic mission to Woodmancote; later she brought her mother, Lady Bird, and was to ask Kipper to her own

Rugby School gate as drawn to illustrate *Tom Brown's Schooldays* (1956), and also the sketch for the drawing. Note the far greater detail in the sketch: that was what Leslie Illingworth called Shepard's 'indulgence'.

Melampus (in Roger Lancelyn Green's *Old Greek Fairy Tales* – 1959)
talking to the woodworms as they ate through the beams of his
prison ceiling; thus he was able to prophesy, miraculously,
exactly when the prison would collapse. With a straightening
of the nose and a slight enlargement of the eyes, Shepard turns
his ordinary English boy into Melampus. But for B. D. Rugh's
Crystal Mountain (1958) the imaginary piece of Greek pottery
discovered is pure caricature – Ulysses at last returning home
to be recognized only by the old dog, Argus.

WHEN WE WERE VERY YOUNG.

IX.—TEDDY BEAR.

A BEAR, however hard he tries,
Grows tubby without exercise.
Our Teddy Bear is short and fat,
Which is not to be wondered at;
He gets what exercise he can
By falling off the ottoman,
But generally seems to lack
The energy to clamber back.

Now tubbiness is just the thing
Which gets a fellow wondering;
And Teddy worried lots about
The fact that he was rather stout.
He thought: "If only I were thin!
But how does anyone begin?"
He thought: "It really isn't fair
To grudge me exercise and air."

For many weeks he pressed in vain
His nose against the window-pane,
And envied those who walked about
Reducing their unwanted stout.
None of the people he could see
"Is quite" (he said) "as fat as me!"
Then, with a still more moving sigh,
"I mean" (he said), "as fat as I!"

Now Teddy, as was only right,
Slept in the ottoman at night,
And with him crowded in as well
More animals than I can tell;

Not only these, but books and things,
Such as a kind relation brings,
Old tales of "Once upon a time,"
And history re-told in rhyme.

One night it happened that he took
A peep at an old picture-book,
Wherein he came across by chance
The picture of a King of France
(A stoutish man) and, down below,
These words: "King Louis So-and-So,
Nicknamed 'The Handsome.'" There he sat,
And (think of it!) the man was fat!

Our bear rejoiced like anything
To read about this famous King,
Nicknamed "The Handsome." There he sat,
And certainly the man was fat.
Nicknamed "The Handsome." Not a doubt
The man was definitely stout.
Why then a bear (for all his tub)
Might yet be named "The Handsome Cub!"

"Might yet be named." Or did he mean
That years ago he "might have been"?

For now he felt a slight misgiving:
"Is Louis So-and-So still living?
Fashions in beauty have a way
Of altering from day to day;
Is 'Handsome Louis' with us yet?
Unfortunately I forget."

Next morning (nose to window-pane)
The doubt occurred to him again.
One question hammered in his head:
"Is he alive or is he dead?"
Thus nose to pane he pondered; but
The lattice now low, loosely shut,
Swung open. With one startled "Oh!"
Our Teddy disappeared below.

There happened to be passing by
A plump man with a twinkling eye,
Who, seeing Teddy in his feet,
Raised him politely to his ear
And murmured kindly in his ear
So't words of comfort and of cheer:
"Well, well!" "Allow me!" "Not at all."
"Tut-tut! A very nasty fall."

Our Teddy answered not a word;
It's doubtful if he even heard.
Our bear could only look and look:
The stout man in the picture-book!
That "handsome" King—could this be he,
This man of adiposity?

"Impossible," he thought; "but still,
No harm in asking. Yes, I will!"

"Are you," he said, "by any chance
His Majesty the King of France?"
The other answered, "I am that,"
Bowed stiffly and removed his hat;
Then said, "Excuse me," with an air,
"But is it Mr. Edward Bear?"
And Teddy, bending very low,
Replied politely, "Even so."

They stood beneath the window there,
The King and Mr. Edward Bear,
And, handsome, if a trifle fat,
Talked carelessly of this and that . . .
Then said His Majesty, "Well, well,
I must get on," and rang the bell.
"Your bear, I think," he smiled. "Good-day!"
And turned and went upon his way.

A bear, however hard he tries,
Grows tubby without exercise;
Our Teddy Bear is short and fat,
Which is not to be wondered at.
But do you think it worries him
To know that he is far from slim?
No, just the other way about—
He's proud of being short and stout.

A. A. M.

'Teddy Bear' from *When We Were Very Young*.
On rolled and tumbled Winnie-the-Pooh.

wedding at the White House. Kipper, still willing to travel almost any-
where, did not feel himself strong enough for that journey. On rolled
and tumbled Winnie-the-Pooh, with Kipper doing new colour, colour-
ing old drawing, producing fresh dust-jackets and even new line.
There were a Pooh Cook Book, a Pooh Party Book and a Pooh Song
Book. Kipper did confess in private (but only in private, for he was too
honest and too sensible to deny the value of his bread and butter) that
he was getting rather tired of that 'silly bear'. But by the mid 'sixties
he was doing better out of Pooh than ever before. He was not, as
Roger Hunt, Minette's husband and a respected figure in the insurance
world, has remarked, the kind of artist who doesn't know whence the
money came or care whither it goes. 'When I went formally to ask
Kipper for his granddaughter's hand in marriage, one or two people
drifted into the room as we talked, and he suggested we went for a
walk in the garden. I shall never forget the smile of relief that came
into his face when I told him that I was actually in receipt of a regular
monthly income.' Old Uncle Willie would have been proud of Kipper.

Doodles in fish.

The Shepards quickly made friends in Lodsworth, as they had at
Meadow Down. Kipper, who had been emotionally religious in his late
teens and early twenties, had now settled into a contented belief in the
established church. At Guildford he had interested himself con-
siderably in the building of the new cathedral there, and now he was a
willing helper in the parish work of the lovely church of St Peter's at
Lodsworth. His last cartoon for *Punch*, the appeal for the World
Churches, had been published in large part at his own urging. He
liked, as he had at Long Meadow, the society of friendly neighbours,
and he was very much the good bourgeois Christian. Perhaps because
of his poverty in youth, Kipper had always been prudent about
money. Much of his early correspondence with Norah, both before
and after they were married, had concerned bonds and shares he was
putting in her name, for she professed ignorance about money matters.
The principles and beliefs he had been brought up with in Gordon
Square, stayed with Kipper strongly. Among professional friends, the
one who remained closest to him was Leslie Illingworth, once a fellow
cartoonist with Kipper on *Punch*, who lives at Robertsbridge in East
Sussex (as also – it so happens – does Malcolm Muggeridge).

In the late 'forties Illingworth was cartooning both for *The Daily Mail*
and *Punch*. A kind and enthusiastic Welshman, he says he would rather
than anything have been a farmer in Glamorgan – but he had a gift for
drawing and, like Kipper, the will to work at it. His arrival at the *Punch*

The rather cocky little boy
who defied the bears
in 1924 has become a
more demure young man in
*The Christopher Robin Book
of Verse* in 1969.

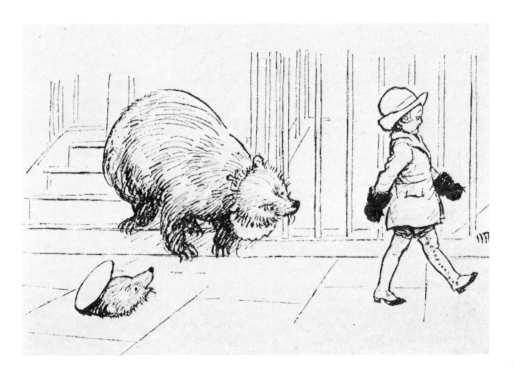

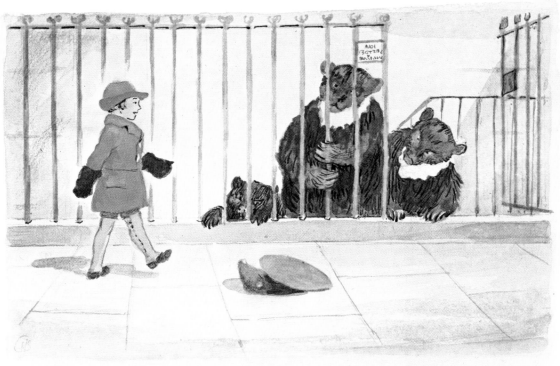

Sketch fi Vespers W.W.W.V.Y.

Shepard was still doing new sketches
for the colour version of *Vespers* in 1969.

DINKIE BINKER

Binker

DINKIE—what I call him—is a secret of my own,
And Dinkie is the reason why I never feel alone:
Playing in the nursery, sitting on the stair,
Whatever I am busy at, Dinkie will be there.

Oh, Daddy is clever, he's a clever sort of man,
And Mummy is the best since the world began,
And Nanny is a Nanny, and I call her Nan—
But they can't
See
Dinkie.

Dinkie's always talking, 'cos I'm teaching him to speak:
He sometimes likes to do it in a funny sort of squeak,
And he sometimes likes to do it in a hoodling sort of roar . . .
And I have to do it for him 'cos his throat is rather sore.

Dinkie's brave as lions when we're running in the park;
Dinkie's brave as tigers when we're lying in the dark;
Dinkie's brave as elephants. He never, never cries . . .
Except (like other people) when the soap gets in his eyes.

Oh, Daddy is clever, he's a clever sort of man,
And Mummy knows all that anybody can,
And Nanny is my Nanny, and I call her Nan—
But they don't
Know
Dinkie.

*This is the poem written by A. A. Milne in 1925 and
published in Pears' Annual: The alterations are in Milne's
handwriting before the poem was published in "Now we are Six" E.H.Shepard*

234

The 'mummy' of Dinkie, who became Binker,
went through some changes over the years.
The alterations to the original verse are in Milne's own hand.

table alarmed him. 'I didn't know how to go about it among this curious collection of gents.' But Kipper was there, and to him he could always talk. What about? 'He was great about the country. How the cows, how the vegetables were doing. He was a man for all men.' How often that phrase, or a variant of it, echoes back from those who knew Kipper. At the *Mail* they had a morning conference on the cartoon at which everyone threw in his suggestions 'including the sports fellows.' Then you went along to the editor's office and he fixed it all in three or four minutes. At *Punch* it was different. 'All those gents' talked around a host or erudite ideas and inspirations 'and in the end you were really left to work it out for yourself.

'Kipper wasn't bothered by all the clacketing in the office about who had what position or title. He had it all, you see. He could do it. I don't think Kipper or I had our hearts in political cartoons. We'd do them. We were professionals. There had been some who'd really throw their hearts into them. But there was one great thing. You could do a real picture there, after all those intellectual gents had put in their suggestions. Kipper and I both felt that.'

It is Illingworth's belief that Kipper's final drawing was always intuitive – 'somnambulistic,' he calls it; and anyone who has known Kipper coming towards him with those big light blue eyes gazing at him in obvious welcome, and yet not precisely at him, but through him and into space, will know what he means. I pointed out to Illingworth the care Kipper took with preliminary sketches: sometimes there are half a dozen for one drawing. 'I think, you know, that was a bit of *indulgence*. He was so good at it, you see. He enjoyed doing all those perfectionist bits he wasn't going to use in the end.' 'So you think the final work just came to him in a flash?' 'I think so. Except that it came when he was somnambulistic. He was great like that.' That is an artist's view of an artist, though I confess I find it rather hard to accept. Both did indeed appreciate one another as craftsmen. Illingworth never lost touch with Kipper, coming to all his birthday parties at Lodsworth, even the last one, the ninety-sixth.

From Hans Andersen's *Fairy Tales* (1961).

After finishing two books of reminiscences Kipper now well into his eighties, launched out into the tumbled seas of authorship for children. In 1965 came *Ben and Brock*, the story of a ten year-old country boy and a badger – that badger again! – whose ancestral underground home is discovered to be partly occupied as a smuggler's cave. In the next year Kipper followed it with *Betsy and Joe*, which tells of a tramp who be-

The Wild Swans

237

friends a squirrel. The tramp is an old soldier of the first World War, and in its original form the book was mainly concerned with reminiscences of war. But when his publishers suggested that a little more action was needed in a children's book, Kipper was quite happy to take advice. So Betsy, kidnapped to do a high wire act, is rescued by the friendly circus boy, Dan. The two books are not the most magnetic of children's tales, but their publication gave Kipper great pleasure, and of course they got off to a good start with his own drawings.

By now news of the extent of his work, and of his admirers, had penetrated Whitehall, and in 1972, seventy-one years after he had first exhibited in the Royal Academy, Ernest Howard Shepard was awarded the Order of the British Empire.

Kipper was over ninety when he did his last work for publication, colouring his original line drawings for *Winne-the-Pooh* and *The House at Pooh Corner*, which then went into further editions. He had become very deaf, but that didn't daunt him and he would walk cheerfully out of the gate of Woodmancote which opens on to a road that is a short cut for traffic between the Haslemere district and one of Sussex's few main east-west routes, the A272. Accompanied by his old dog he would wander not too steadily up the main street, hailing all and sundry, who would watch in agony as unheard motor vehicles thundered up behind him. He remained lucky, as always in the matter of physical danger, but in the last few years his eyes failed and that was a curse he found hard to bear. He had always been able to use his eyes to so much better effect than his friends used theirs, and he knew it, and now he wasn't interested in the world as they described it. Norah had been ill, off and on, for some years too, and that added greatly to his worries. He died in 1976, when preparations were being made to celebrate the 50th anniversary of the publication of *Winne-the-Pooh*, festivities in which, I am sure, he would have indomitably joined, despite his growing handicaps.

He never really changed – until, perhaps he grew too old to care very much; and if he ceased to care at the end, that was only because he was unable to work, and work – art – had meant more to him than anything else in life. He might not have chosen to be remembered as the visual creator of Winne-the-Pooh and Toad of Toad Hall; but it must have given him many wry smiles in later years when he found that the demand for his original drawings of these animals, up to their various antics, grew so insistent that it drove up the prices of 'Shepard' oil and water colour paintings he had done largely for pleasure. He would

Six preliminary sketches for a single *Punch* drawing.

239

think that just as amusing and unlikely as when he sold his first Academy
painting to the gallery at Durban, married Florence and went to live in
Arden Cottage, 'and what had seemed impossible a few months earlier
had come to pass.'

(*Left*) from 'The House that Jack Built' and (*right*) from
'The Gingerbread Boy' in *The Pancake*, Ginn, 1957.

From 'Mother Frost'
in *Briar Rose*, Ginn, 1958.

From 'Alice and the White Knight'
in *A Noble Company*, Ginn, 1961.

A master of line

by Bevis Hillier

Art historian and former editor of The Connoisseur

One of the first stories I had to write when I became Sale Room Correspondent of *The Times* in 1968 was about the sale at Sotheby's of E.H. Shepard's illustration for *Winne-the-Pooh* showing Pooh and his friends eating *al fresco* at a long table. The pen-and-ink drawing went to Quaritch for £1,200, which then seemed a huge sum for a living illustrator. 'It was a case of hush, hush, whisper who dares, as bidding, which began at £200, jumped up by £50 bids to this surprising total.' Shepard's old employer, *Punch*, picked up the story of the sale, and turned it into a funny poem á *la* Pooh:

> *Sotheby, Botheby, tiddeley-pom,*
> *A sketch of my picnic has sold for a bomb.*

I had known Shepard's work since the year of my birth, as I was named from Richard Jefferies' *Bevis: the Story of a Boy*, of which I received the Shepard-illustrated edition of 1932 at Christmas 1940, when I was nine months old. When you and the hero of a children's book are, to the best of your limited knowledge, the only two in the world bearing a certain name, you inevitably tend to identify with him. The name starts out of the page at you. The fictional Bevis – raft-building, tree-climbing, handy with an axe – could hardly have been more different from the pallid swot I became; yet I liked his imperiousness, his readiness to assume the lead, and the uninhibitedly selfish way he lorded it over his friend Mark.

So I grew up with Shepard's illustrations to *Bevis*, and loved them. Often one finds that the things one admired as a child look trumpery to the adult; but a more tutored eye has only given me a deeper appreciation of Shepard's mastery. My favourite drawing always was, and still is, the one on page 33, '*The willow was obstinate*'.
If I try to analyse its appeal (which seems as offensively clinical as analysing why one likes one's family) I first observe how well it represents the passage it illustrates:

> The raft came to another bend, and Bevis with his pole guided it round, and then, looking up, stamped his foot with vexation, for there was an ancient, hollow willow right in front, so bowed down that its head obstructed the fair way of the stream. He had quite hoped to get down to the Peninsula . . . But the willow was obstinate.

Next, consider the power of the composition. The main line of Bevis's body, which is continued in a leaning tree faintly suggested at the top of the drawing, forms a diametric cross with the willow bole. You can sense the push of his left arm against the old tree – just as you can feel

'The willow was obstinate' from *Bevis*.

the weight of the mast against his shoulder in 'The mast fitted', a later illustration.

Only a few artists have been able to petrify movement so as to convey a still continuing force. Lautrec – who, we should remember, was only fifteen when Shepard was born – is among them: Merete Bodelsen has written of his 1893 Jane Avril poster: 'In the photograph, Jane Avril is a woman who lifts one of her legs; in Lautrec's drawing she acts and dances.' In a drawing, this tension of suspended movement is like the conflict between characters which sustains our interest in a novel or play. It is the aspect of Shepard's work which his followers have most often tried, and most often failed, to achieve.

What else typifies a Shepard drawing? A fastidious clarity of line. A Vermeer-like consciousness of light direction. A nice judgment of where to set the boundaries of a vignette, with a fuzz of foliage, a white rock, densely cross-hatched night sky or a line of stunted pollards. And a genius for pointing up a telling detail – for example the garden sieve hanging on the wall in the second *Bevis* illustration, its sides splitting and springing apart, and, in the same drawing, the mess of curly wood-shavings under the workbench vice.

As with Tenniel's illustrations to the *Alice* books, one feels no illust-rations could ever replace Shepard's for *Bevis*. With *The Wind in the Willows* he had a formidable rival in Arthur Rackham, whose gnarled drawings have been described as 'the evil of all roots'; but to me Shepard's drawings are still the canonical ones. Nobody else's Mr Toad could ever be so egregiously conceited, no one else's Mole so velvetly self-effacing. With the Milne illustrations, I am in a difficulty. I cannot – forgive the pun – bear Pooh, or any of his twee retinue, with the pos-sible exception of the misanthropic Eeyore. But, I can see that nothing could ever satisfactorily replace Shepard's pictures.

The endearing modesty which shines from Shepard's two volumes of autobiography (and makes one wonder how he ever steeled himself to write them) made him the perfect illustrator. Like Gerald Moore, the accompanist, who called his memoirs *Am I Too Loud?*, Shepard never allows his own personality to obtrude in what is also, after all, a form of accompaniment. He translates, never transmutes.

What, finally, is Shepard's place in the history of English illustration? I see him as the end of a tradition, not the beginning of one. He is the

'The mast fitted' from *Bevis*.

last of the great Victorian 'black and white' men. He has more in common with his beloved Charles Keene than with any other artist, and the debt he owed him is obvious; but there are also strong affinities with du Maurier, F.H.Townsend, the first art editor of *Punch*, and the *Punch* illustrator H.M. Brock (who, incidentally, called his son Bevis.) Caran d'Ache, the marvellously deft French cartoonist, was an influence on all that generation, and had Shepard's power to suspend animation as well as disbelief. Phil May was the nearest English equivalent to Caran d'Ache, but his ruthlessness in eliminating lines went far beyond Shepard's: 'Fougasse' (Kenneth Bird) was a more obvious inheritor of May's style.

The European illustrator of children's books whose work most resembles Shepard's is the Swedish artist Carl Larsson, whose delightful works *Our Home* and *Our Farm* have become popular in England in the version by Olive Jones published by Methuen Children's Books. The similarity between the two men's styles is extraordinary: at times they are almost interchangeable. Yet there is no evidence that either knew the other's work, and certainly *Our Home*, published in Sweden in 1899, must have been illustrated in ignorance of Shepard. Both men's draughtsmanship shows a flawless underlying awareness of human anatomy. Such is their sureness that neither needs to scribble in a preliminary imbroglio of lines from which the final design is to be teased out, as in a Topolski or even an Augustus John drawing. Their line takes an unerring, seemingly pre-ordained course, like that of Holbein or Ingres. But quite apart from the similarities of draughtsmanship, which extend even to certain recurrent postures of figures, the two artists have an unsentimental understanding of children which recalls the 'Eustace and Hilda' novels of L.P. Hartley – in which the creator so completely manages to put himself inside the child's skin that one suspects a case of 'arrested development'. Richard Jefferies had the same gift, which is one reason why Shepard was so ideal an interpreter of *Bevis*.

Not long after the Sotheby sale of the Pooh drawing, a number of Shepard's drawings for *Bevis* came up in a small Sussex auction room. They did not include the drawings I most coveted, so I put in no bid; but, thinking Shepard might be selling off his past work, I wrote to ask if he would consider selling me 'The willow was obstinate'. He replied that unfortunately 'The willow' and other *Bevis* originals had been sold in a Foyle's gallery exhibition years before, he did not know to whom. So I possess no Shepard drawing; but it pleases me that I have a sample

Examples of the unerring eye for detail and
underlying awareness of human anatomy shared by
Shepard with the Swedish artist, Carl Larsson.
(*Left*) Larsson's water colour from *Our Farm* and
(*right*) Shepard's line drawing for *Bevis*.

of his neat, nonagenarian handwriting and that, before he died, I was
able to express to him the delight that his drawings of my eponymous
namesake have given me, literally from the cradle.

Bibliography and Acknowledgements

The list of books beneath the chapter numbers below contains all the English language works I believe to have been illustrated by Ernest Shepard. Unfortunately that does not mean that it is either complete or accurate – only as much of either as I can make it. The cataloguing of authors alongside artists who have worked with and for them seems to have been a haphazard business, even in the most respected of museums and libraries. I have not intended to include books when Shepard had only designed the dust-jacket, since dust-jackets, however handsome, are ephemeral things, not even preserved by the British Museum, for instance. But I cannot be sure, especially with the early works, that I have strictly observed this rule.

For those who wish to look at source material, the University of Surrey, where the librarian and his staff were most kind and helpful to me, holds the bulk of Shepard's personal papers. There is a very good collection of originals of his *Punch* political cartoons at the University of Kent. The Victoria and Albert Museum has the original sketches for *Winnie-The-Pooh* and *The House At Pooh Corner*, and the Imperial War Museum a number of paintings done by Shepard while he was a gunner between 1916 and 1919.

It will be understood that those to whom I accord my grateful acknowledgements below are the sole copyright holders of the Shepard pictures here linked to their names, and that there can therefore be no further reproduction without their permission. For the sake of brevity, I have coded my main sources thus:

M H	By kind permission of Mrs Minette Hunt
M K	,, ,, Mrs Mary Knox
M	,, ,, Messrs Methuen Ltd, and successor companies
B H	,, ,, Messrs Bell & Hyman Ltd
G	,, ,, Messrs. Ginn & Company Ltd
J C	,, ,, Messrs. Cape (Jonathan) Ltd
P	,, ,, the proprietors of *Punch*
I P C	,, ,, IPC Magazines Ltd
O U P	,, ,, The Oxford University Press
V A	,, ,, The Victoria & Albert Museum
B L	,, ,, The British Library

RAWLE KNOX

CHAPTER I (1879–1897)
Pictures in Text
6, M H; 9–11, *Drawn From Memory* M; 13, M H; 14, *Drawn From Memory* M; 15, M H; 17, *Drawn From Memory* M; 19, 20, M H; 21–29, *Drawn From Memory* M; 33–41, *Drawn From Life* M; 43, M K; 44, *Drawn From Life* M.

CHAPTER II (1897–1914)
Pictures in Text
45–53, M H; 54, M K; 55, P; 57, top left M H, others B L; 59–61, M H; 63, top, By kind permission of the Ashmolean Museum, Oxford; 63, bottom left, M H; 63, bottom right, M K; This sketch, captioned 'Head of a Family Friend,' is in fact (and obviously) a head of Florence, Ernest Shepard's wife. 65, 66, I P C; 67, M H; 69, top, M K, bottom B L; 71, 72, M H; 73, P; 74, I P C; 75, P; 77, M H; 78, top, M H, bottom, M K.
Books Illustrated (between 1900 & 1914)
Tom Brown's Schooldays Thomas Hughes
David Copperfield Charles Dickens
Aesop's Fables Rhymed by the Rev. G. Henslow
Henry Esmond W. M. Thackeray
Play The Game! Henry Alsop
Money or Wife Effie Adelaide Rowlands
Smouldering Fires Evelyn Everett-Green

CHAPTER III (1914–1920)
Pictures in Text
79 (see 95, top); 81–83, M H; 84, M K; 85, P; 87–89, M K; 91, top, M H, bottom, P; 92, 93, M H; 95, top, By kind permission of the University of Surrey; 95, bottom, P; 97, M H; 98, left, M H, right, M K.
Books Illustrated 1919
Jeremy Hugh Walpole, Macmillan

CHAPTER IV (1920–1940)
Pictures in Text
99, *Winnie-The-Pooh* M; 101–105, M H; 107, P; 108, top, M H; bottom, M; 109–111, B H; 114, V A; 115–117, M; 118, V A; 119–125, M; 126, V A; 127–136, M; 137, top, M, bottom, By kind permission of Mrs Iva Hill; 138, V A; 139, M; 140, V A; 141, M; 142–145, M H; 147, M; 148, By kind permission of Messrs. J. Saville & Co. 149, 150, M H; 151, J C; 152, M H; 153, P; 154, J C; 155 P; 156, M; 157, M H; 158–177, M; 178, By kind permission of Messrs. Blackwood (William) & Sons Ltd. 179, M H; 180, P; 181, 182, M K.
Books Illustrated
1924
Everybody's Book of the Queen's Doll's House
ed. by A.C. Benson and Sir Lawrence Weaver, Methuen/ Daily Telegraph
When We Were Very Young
A. A. Milne, Methuen/Dutton USA
1925
A Book of Children's Verse
E. V. Lucas, Doran USA
Fourteen Songs from When We Were Very Young
A. A. Milne (with music by H. Fraser Simson, and some new drawings by EHS), Dutton USA

The King's Breakfast from W.W.W.V.Y.
A. A. Milne (with music by H. Fraser Simson, and some new drawings by EHS), Dutton USA
1926
Teddy Bear and Other Songs from W.W.W.V.Y.
A. A. Milne (with music by H. Fraser Simson, and some new drawings by EHS), Dutton USA
Everybody's Pepys
ed. by O. F. Morshead, Bell/Harcourt USA (1931)
The Holly Tree and Other Stories
Charles Dickens, Scribner USA
1927
The Little One's Log
Eva Erleigh (Later Marchioness of Reading), Partridge
Now We Are Six
A. A. Milne, Methuen/Dutton USA
Let's Pretend
Georgette Agnew, Methuen/Putnam USA
Fun and Fantasy
Punch anthology ed. by EHS, Methuen
1928
Mr Punch's County Songs
E. V. Lucas, Methuen
The House at Pooh Corner
A. A. Milne, Methuen/Dutton USA
The Golden Age (limited edition)
Kenneth Grahame, John Lane/Dodd USA(1929)
1929
Livestock in Barracks
Anthony Armstrong, Methuen
The Very Young Calendar
A. A. Milne, Dutton USA
1930
Everybody's Boswell
ed. by F. V. Morley, Bell/Harcourt USA
Dream Days
Kenneth Grahame, John Lane/Dodd USA (1931)
When I was Very Young
A. A. Milne, Methuen/Fountain Press USA
1931
The Wind in the Willows
Kenneth Grahame, Methuen/Scribner USA (1933)
Christmas Poems
John Drinkwater, Sidgwick & Jackson
1932
Sycamore Square
Jan Struther, Methuen
Bevis
Richard Jefferies, P. Smith
1933
Everybody's Lamb (new title page by EHS, 1950)
ed. by A. C. Ward, Bell
The Cricket in the Cage
Patrick Chalmers, MacMillan
The Goblin Market
Laurence Housman, Cape

The Great Cham
(Dr Johnson), Bell
1934
Victoria Regina
Laurence Housman, Cape
1935
Perfume from Provence
Winifred Fortescue, Blackwood
1936
The Modern Struwelpeter
Jan Struther, Methuen
1937
As the Bee Sucks
E. V. Lucas, ed. by EHS, Methuen
Cheddar Gorge
J. C. Squire, Collins/Macmillan USA
Sunset House (frontispiece only by EHS)
Winifred Fortescue, Blackwood
1938
The Reluctant Dragon (previously a single chapter in *Dream Days*; now with fresh drawings by EHS)
Kenneth Grahame, Holiday House USA

CHAPTER V
Pictures in Text
183, (see 197); 185, P; 187, left, P, right, MH; 189, P; 190, 191, MH; 193, top, P, bottom, MH; 194, 195, P; 197, By kind permission of Mr H. F. Ellis. The characters concerned are, left to right. Mlle Richard, H. F. Ellis, Sir Alan Herbert (standing), George Morrow (with pipe), Eric Keown (with flag), E. V. Knox, Bernard Hollowood. 198, 199. By kind permission of Mr H. F. Ellis. Pictured left to right (excluding Mr Punch and the manservant) are: (back) E. V. Knox and Ernest Shepard, (front) Sir Alan Herbert and P. G. Wodehouse. 200, MH.

CHAPTER VI (1940–1955)
Pictures in Text
201, (see 206); 203, MH; 205–207, MK; 208, MH; 209, top, MH, bottom, P; 211, MH; 212, top, MH, bottom, M; 213–215, P; the date of the cartoon on p. 213 is Christmas, 1926. 216, OUP; 217, P; 218, 219, By kind permission of Messrs Collins (William), sons and Co., Ltd. 220, MH.
Books Illustrated
1941
Gracious Majesty
Laurence Housman, Cape/Scribner USA (1942)
1945
Bertie's Escapade
Kenneth Grahame, Lippincott USA/Methuen (1949)
1950
The Islanders
Roland Pertwee, Oxford University Press
1951
Enter David Garrick
Anna B. Stewart, J. Lippincott & Co., USA

1952
Year In, Year Out
A. A. Milne, Methuen/Dutton USA
1953
The Silver Curlew
Eleanor Farjeon, Oxford University Press/Viking USA (1954)
1954
Susan, Bill and The Wolf-Dog
Malcolm Saville, Nelson
The Brownies and Other Stories
Juliana Ewing, Dent/Dutton USA
Susan, Bill and the Ivy-Clad Oak
Malcolm Saville, Nelson
The Cuckoo Clock
Mary Louisa Molesworth, Dent/Dutton USA
The Golden Age
Dream Days
new editions of these Kenneth Grahame books, with new
EHS pictures, Dodd USA
1955
The Glass Slipper
Eleanor Farjeon, Oxford University Press/Knopf USA (1956)
Susan, Bill and the Vanishing Boy
Malcolm Saville, Nelson
Frogmorton
Susan Colling, Collins/Knopf USA (1956)
Modern Fairy Tales
ed. by Roger Lancelyn Green, Dent/Dutton USA
Susan, Bill and the Golden Clock
Malcolm Saville, Nelson

CHAPTER VII (1955–1976)
Pictures in Text
221, MH; 224, In the possession of the editor; 223, By kind per-
mission of Messrs Dent (J.M.) & Sons, Ltd. 225, G; 227, top,
G, bottom, MH; 228, top, By kind permission of The Riverside
Press, Cambridge, Mass., USA. 228, bottom, BH. 229, P; 230,
MH; 231, top, P, bottom, M; 272, MK; 233, M; 234, 235, M; 237,
top and bottom left, OUP, bottom right, MH; 238–241, MH;
242–244, G.
Books Illustrated
1956
The Crystal Mountain
B. D. Rugh, Riverside Press USA
The Secret Garden
Frances Hodgson Burnett, Heinemann
Susan, Bill and the 'Saucy Kate'
Malcolm Saville, Nelson
Royal Reflections
Shirley Goulden, Methuen
At the Back of the North Wind
George MacDonald, Dent/Dutton USA
Susan, Bill and the Dark Stranger
Malcolm Saville, Nelson
Tom Brown's School-days
Thomas Hughes, Ginn

1957
The World of Pooh
A. A. Milne, (anthology with 8 new colour plates by EHS),
Dutton USA/Methuen (1958)
Drawn From Memory
E. H. Shepard, Methuen/Lippincott USA
The Pancake
School reader, ed. by J. Fassett, Ginn
1958
The World of Christopher Robin
A. A. Milne (anthology with 8 new colour plates by EHS),
Dutton USA/Methuen (1959)
Old Greek Fairy Tales
Roger Lancelyn Green, Bell
The Briar Rose
School reader, ed. by J. Fassett, Ginn
1961
Drawn From Life
E. H. Shepard, Methuen/Dutton USA (1962)
Fairy Tales
Hans Andersen, Oxford Univ. Press/Walck USA (1962)
A Noble Company
School reader, ed. by J. Compton, Ginn
1962
The Flattered Flying Fish
E. V. Rieu, Methuen/Dutton USA
Pooh, His Art Gallery
anthology of drawings, some new, Dutton USA
1965
Ben and Brock
E. H. Shepard, Methuen/Doubleday USA (1966)
The Pooh Story Book
A. A. Milne (anthology with new line and colour pictures by
EHS), Dutton USA/Methuen (1967)
1966
Betsy and Joe
E. H. Shepard, Methuen/Dutton USA (1967)
1967
The Christopher Robin Verse Book
(another Milne anthology with new line and colour by EHS),
Dutton USA/Methuen (1969)
1971
The Wind in the Willows
(full colour edit.), Methuen
1973
Winnie-The-Pooh
(full colour edit.), Methuen
1974
The House at Pooh Corner
(full colour edit.), Methuen

CHAPTER VIII
Pictures in Text
245–249, JC; 250, M; 251, JC.

Index